Whimsical
～ and ～
WILD

This book is dedicated to Robin Beam.
Thank you for your friendship and advocacy in
bringing so many of my dreams to life!

xoxo
Jane

GET CREATIVE 6
An imprint of Mixed Media Resources
104 West 27th Street
New York, NY 10001

Connect with us on Facebook at facebook.com/
getcreative6

ISBN: 978-1-64021-044-8

Manufactured in China

1 3 5 7 9 10 8 6 4 2

First Edition

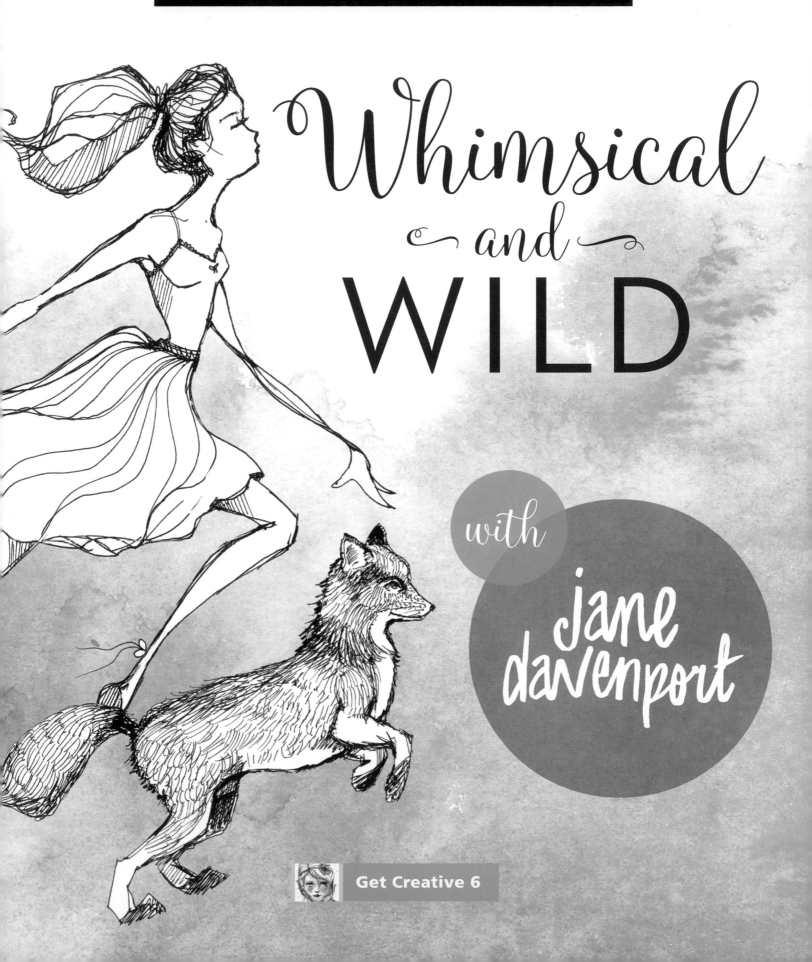

Whimsical
and
WILD

with

jane davenport

Get Creative 6

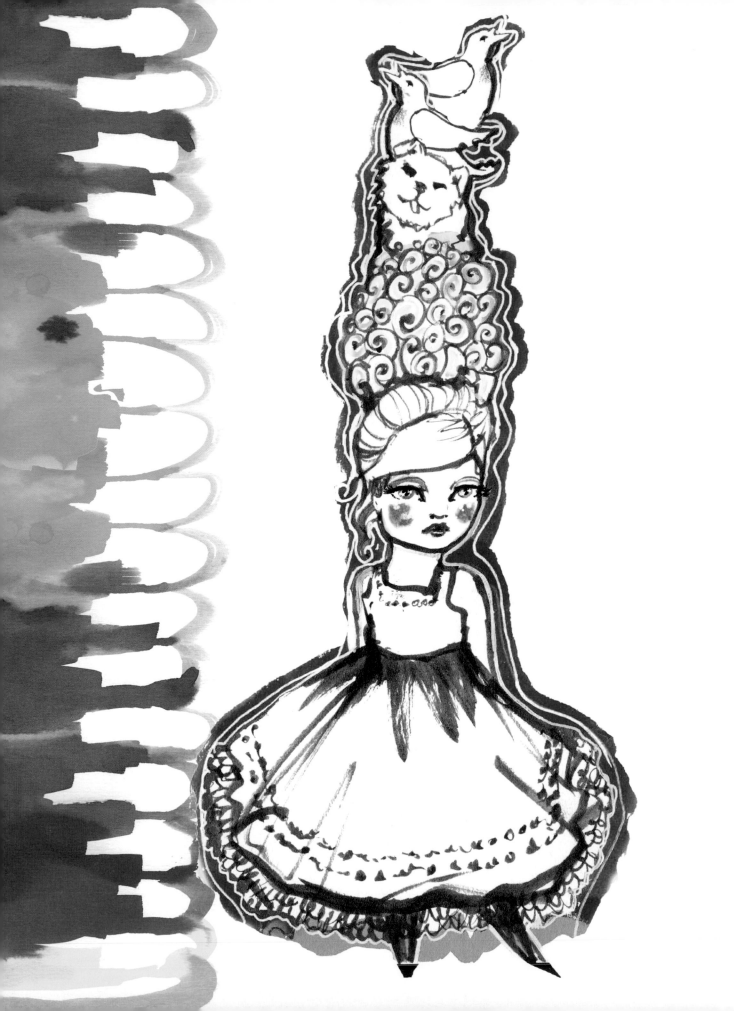

my art journey

My personal creative story is one of encouragement. As a child I just loved to draw, especially animals, and pens were my favorite tools. Fast-forward a few years and here I am, still drawing creatures in ink!

My mum always made sure I had fabulous tools, and my dad spent many hours drawing with my sister and me. At school I was considered a "kid who could draw," but I wasn't especially good.

However, I was willing to take on any challenge, practice, and never give up! In adulthood, my creativity continued as a steadfast ally and, when combined with

a deep fascination with color, carried me from fashion to photography and on to my art career. Art and color give me so much joy, and I want that for everyone!

This passion led me to create my own online art school and community, books, and art supplies. I've always loved to add color to my sketches, and in this book I invite you to do that, too!

.xoxo
Jane

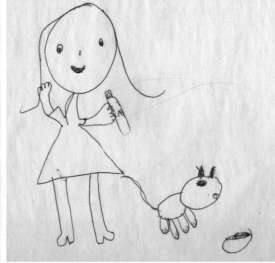

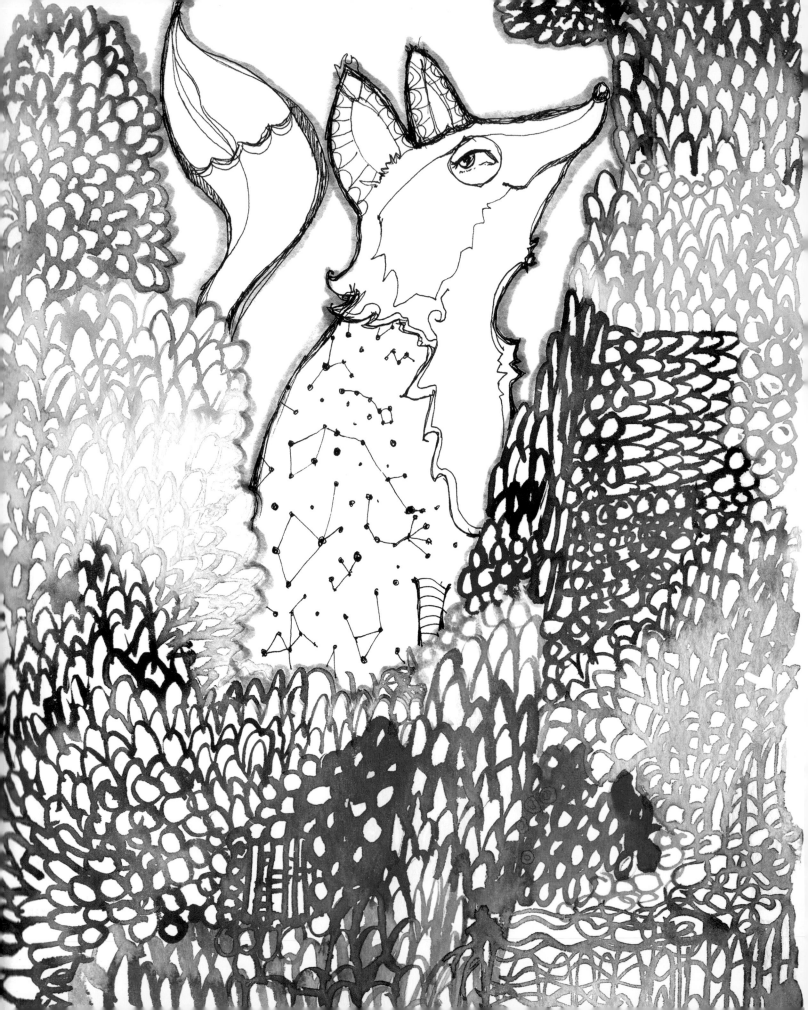

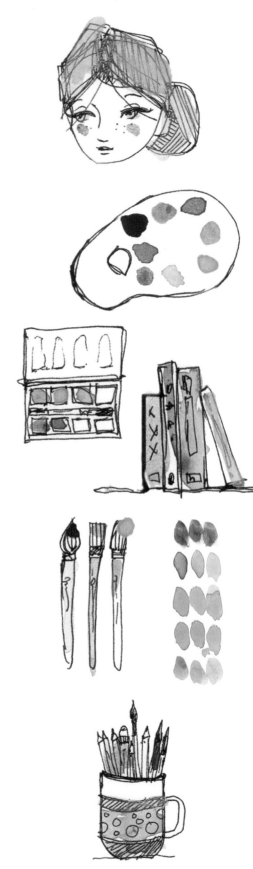

HOW TO USE THIS
art journal

On the right-hand side of each spread is artwork for you to co-create with me. On the left side is artwork from my own journals. This is an "art journal," which means it is for your own personal enjoyment. So let loose and just have fun with color and creativity!

There are six types of creative papers in this book. If you look at the inside margin of each right-hand page you can see the type of paper and suggested media. Each page is perforated so you can remove it to work on, or remove it when you have finished.

• **Coloring paper.** This smooth, wood-free paper is wonderful for pencils, pens, and other dry media.

• **Kraft paper.** This colored paper looks great with pencil, markers, paint pens, gouache, and acrylic paint. Colors leap out of the toned paper. It will wrinkle if it gets too wet, which I find charming, but you may not, so just be aware of its limitations!

• **Mixed-media paper.** This slightly heavier, smooth, wood-free paper can take a little more marker without bleeding through too much. It is great for most media; again, it's not intended for wet media, so go lightly with watercolor.

• **Watercolor paper.** This heavyweight paper is fabulous not only for watercolors but also inks and whatever else you want to use.

• **Collage paper.** A lightweight, origami-style paper that you can pull out, cut, and tear to use as collage paper. Glue it down with a good 'ol glue stick or matte medium.

• **Sticker sheet.** Everyone loves stickers (especially me!). Use them in this book or in your art journal.

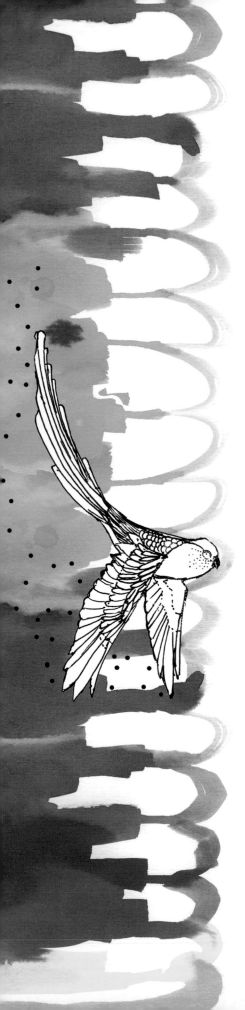

THE IMPORTANCE OF *Creativity*

I know the happiness creativity brings to my own life and the relaxation of mind and untangling of emotion it leads to. The world desperately needs more happiness, and we artistic people can always create a ripple effect.

You and I are probably pretty similar in that we both lead very busy lives, and fitting in art time can be a challenge. I passionately believe that creativity is important, and squeezing in even a few minutes every day can help make you feel more balanced. When you add the minutes of coloring, painting, and drawing from your week, they may add up to a Happy Hour!

Here are some tips on ways to start with art journaling and not lose interest or confidence:

Start the Art
Just get in there and do something—anything! Grab a favorite color in any supply and make some marks. You will be surprised how that awakens the creative muse and leads to more art.

Discover a Creative Community
Join the Jane Davenport Mixed Media Facebook Group, which is full of people sharing their work and techniques with my art supplies and books! It's a supportive, inspiring, uplifting place to enjoy and realize there are people all around the world just like you who love art and creating.

Open to the Middle
This can be a good way to get over "perfectionitis." The perfect white flow of pages is disrupted, so you can now officially not ruin anything! It's only paper anyway, so let loose!

Don't Chase "Your Style"
You can't catch it. It will find you. Style is born of practice. Draw, draw, draw, draw.

I have designed this book so you can add your own style and sensibilities. You can simply add color, but how you do that is up to you! You can draw in extra details. Why not tear and cut shapes from the collage papers and glue them in as new backgrounds?

The mix of papers encourages the use of mixed media (which simply means use anything you want!). My wish for you is to unwind and have fun while building your creative confidence.

If you already keep an art journal, then I hope you enjoy playing with me in this one. And if you have never kept an art journal, I hope that you love this experience and feel inspired to do more!

Happy Hour
TIME SHEET

Whether you can take a block of time or gather little
snippets here and there, track your creative time.
Get in 60 minutes a week, and it's a Happy Hour!

Monday	Tuesday	Wednesday	Thursday	Friday	Saturday	Sunday	Add it together for Happy Hour!

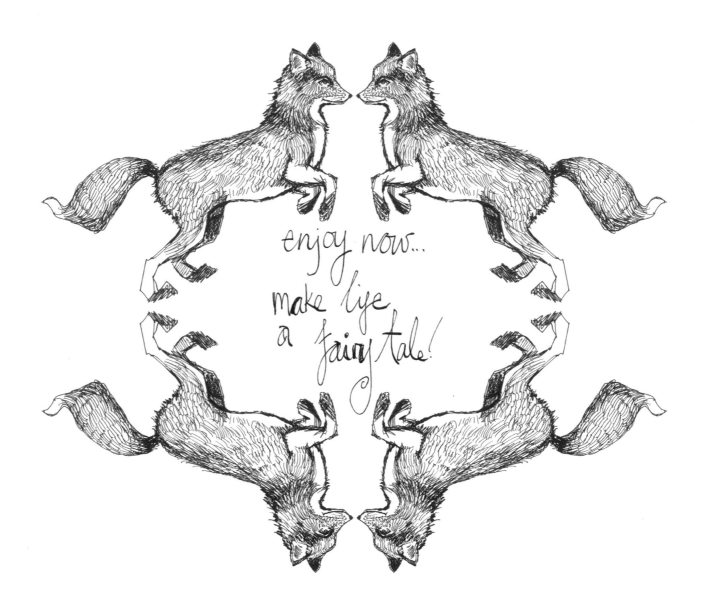

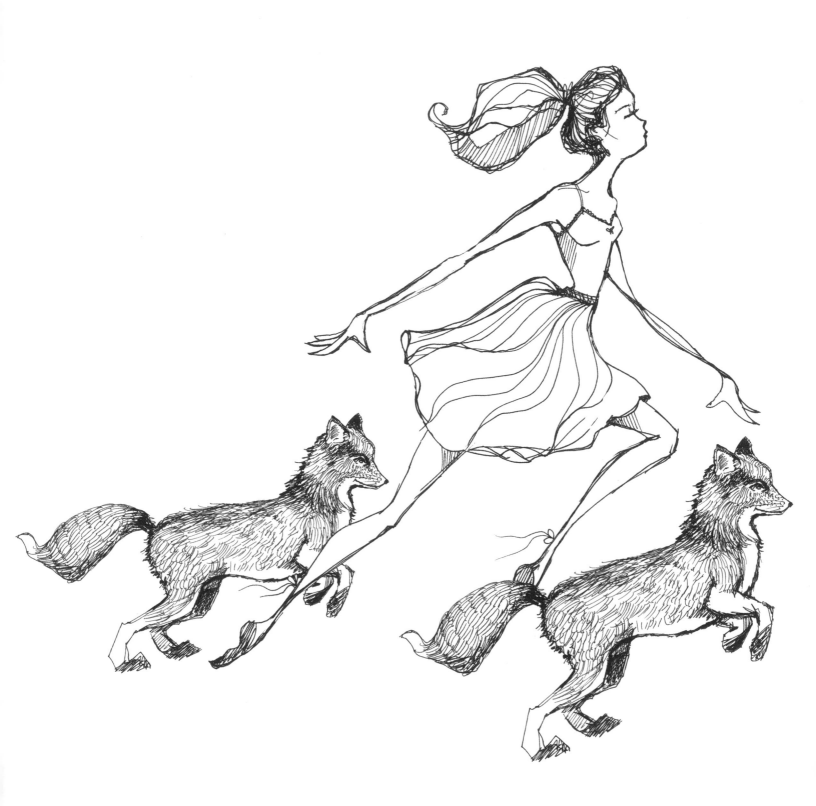

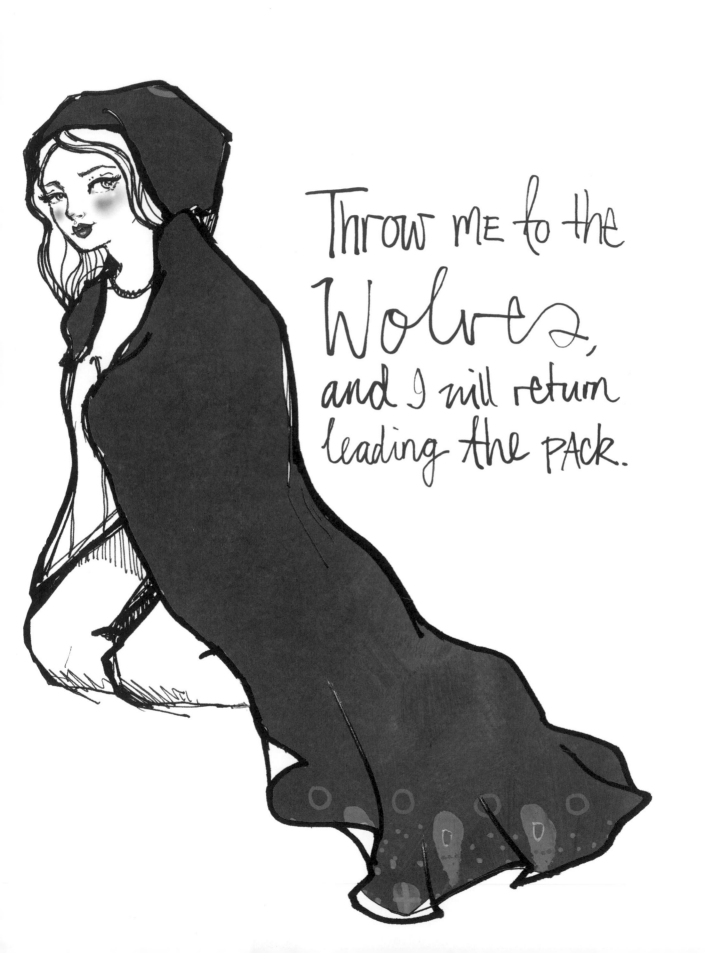

Throw me to the
Wolves,
and I will return
leading the PACK.

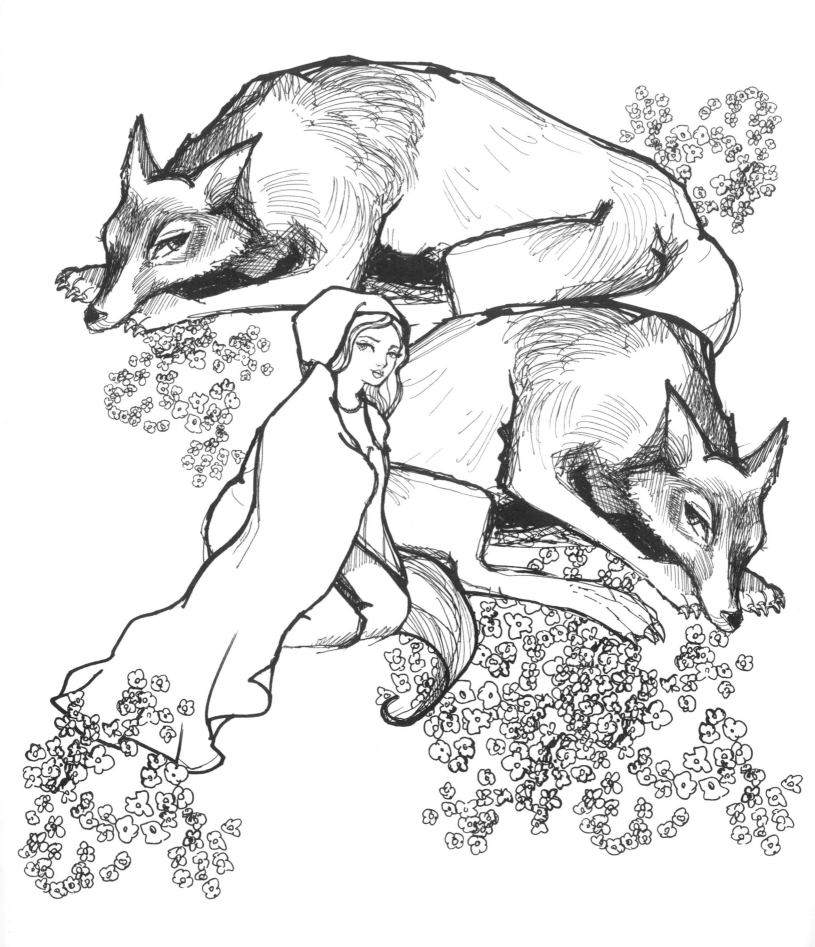

IN ANCiENT times cats were Worshipped as GODS, a fact they have not forgotten.

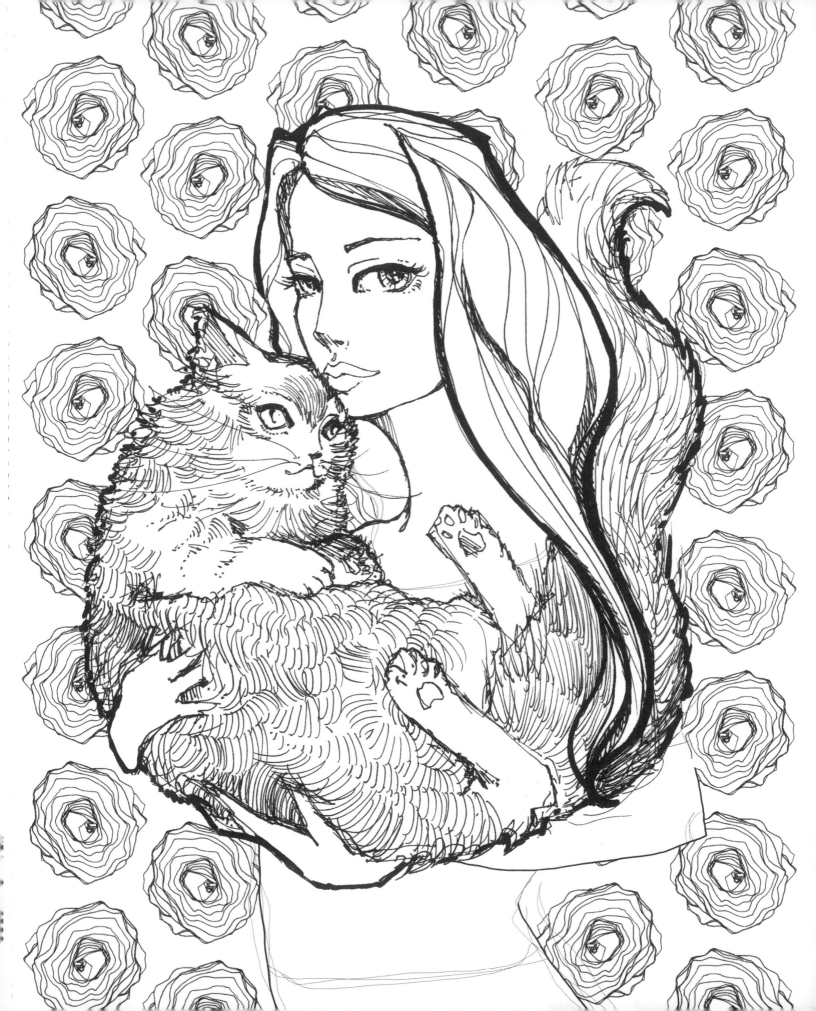

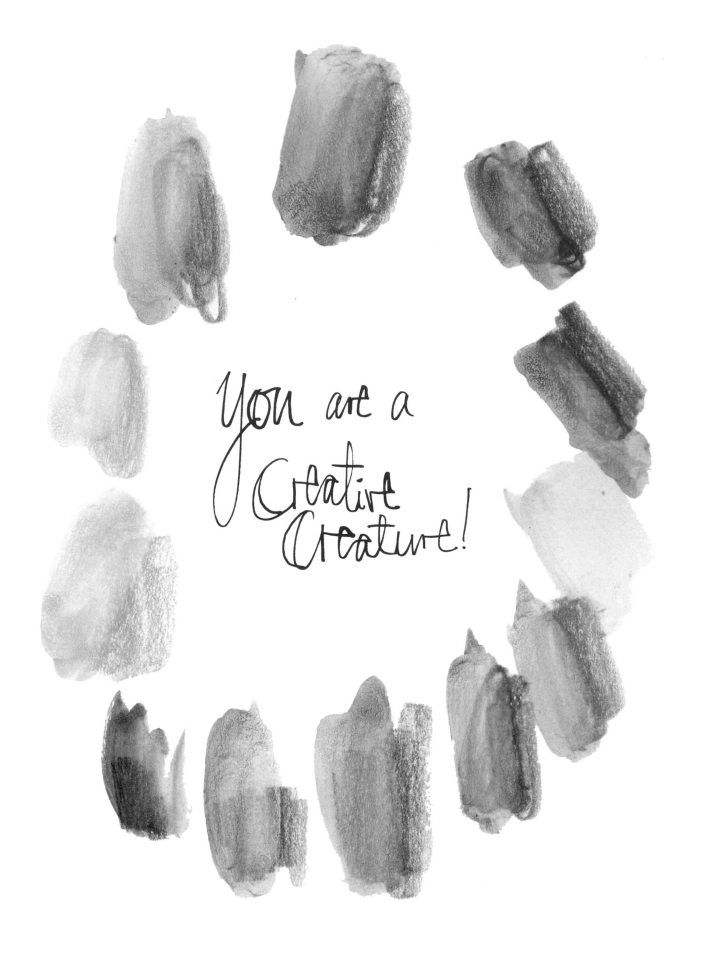

You are a
Creative
Creature!

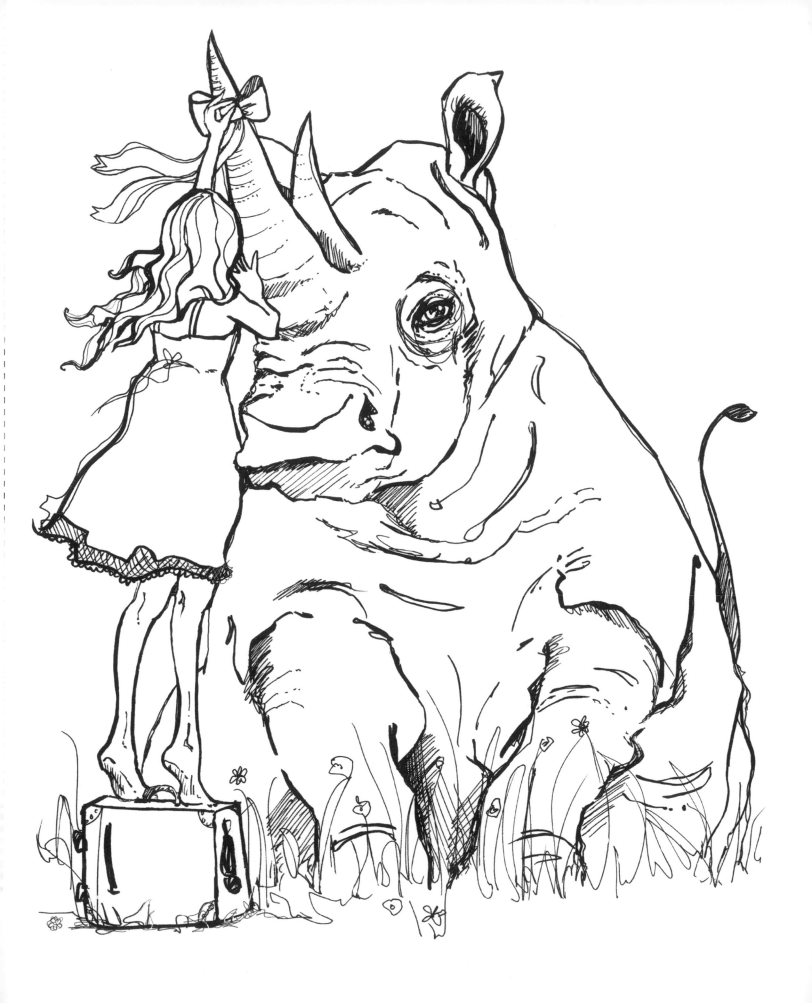

Give me your Magnificent Protection.

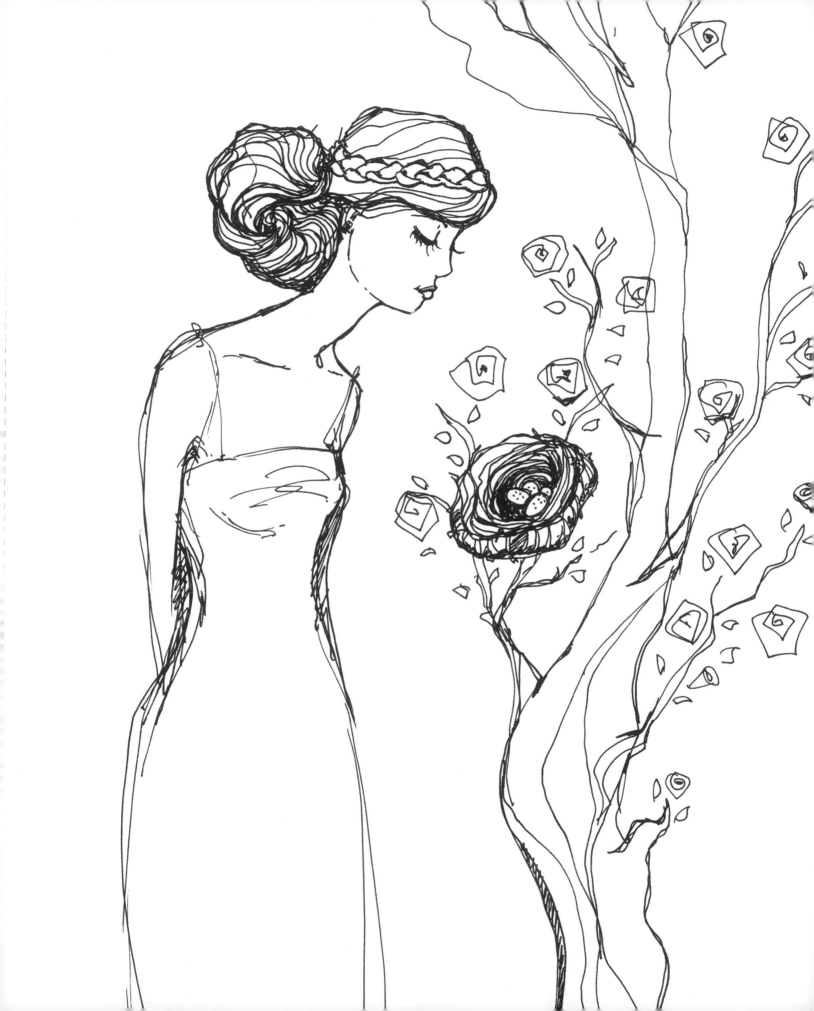

Sometimes you just have to
gather up your
Bravest Self
and head off into
the wild unknown.

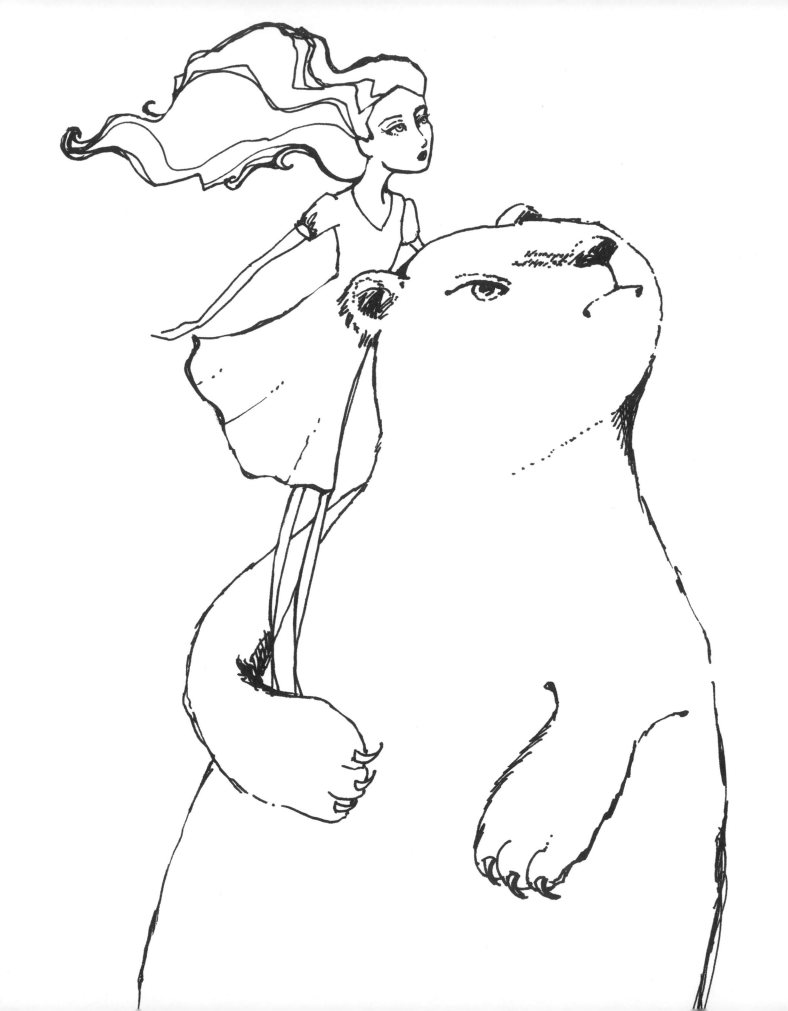

I don't think there is ever a wrong time for a polka dot.

Marc Jacobs

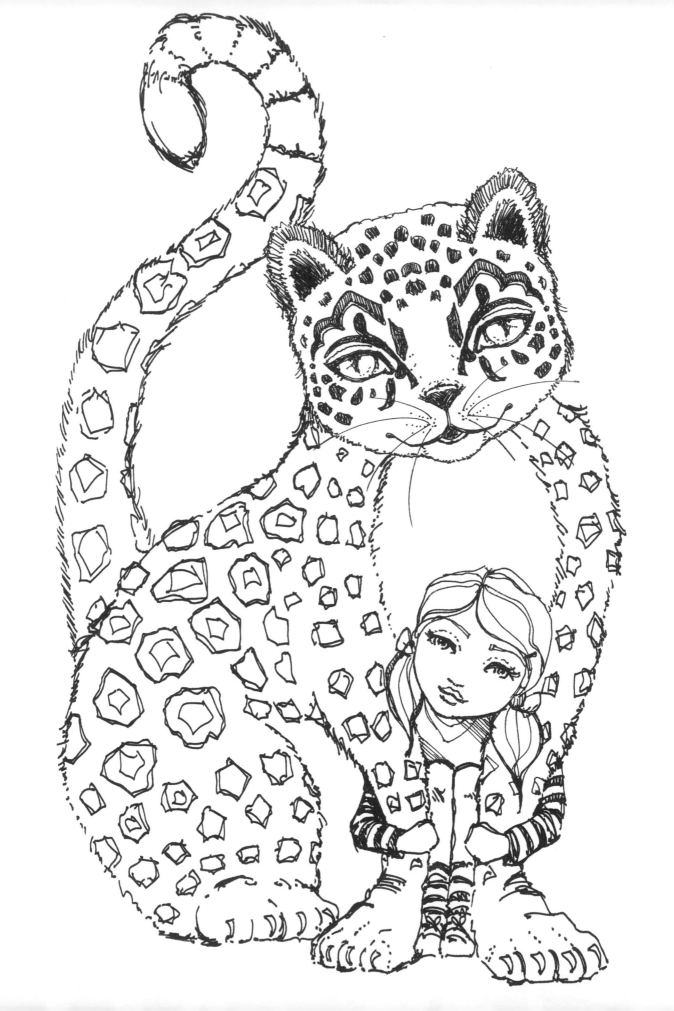

it feels so GOOD to tell the TRUTH

FOXY BROWN

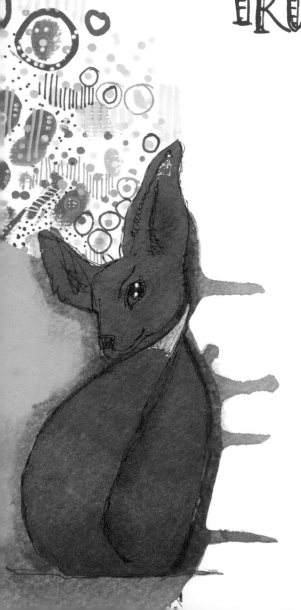

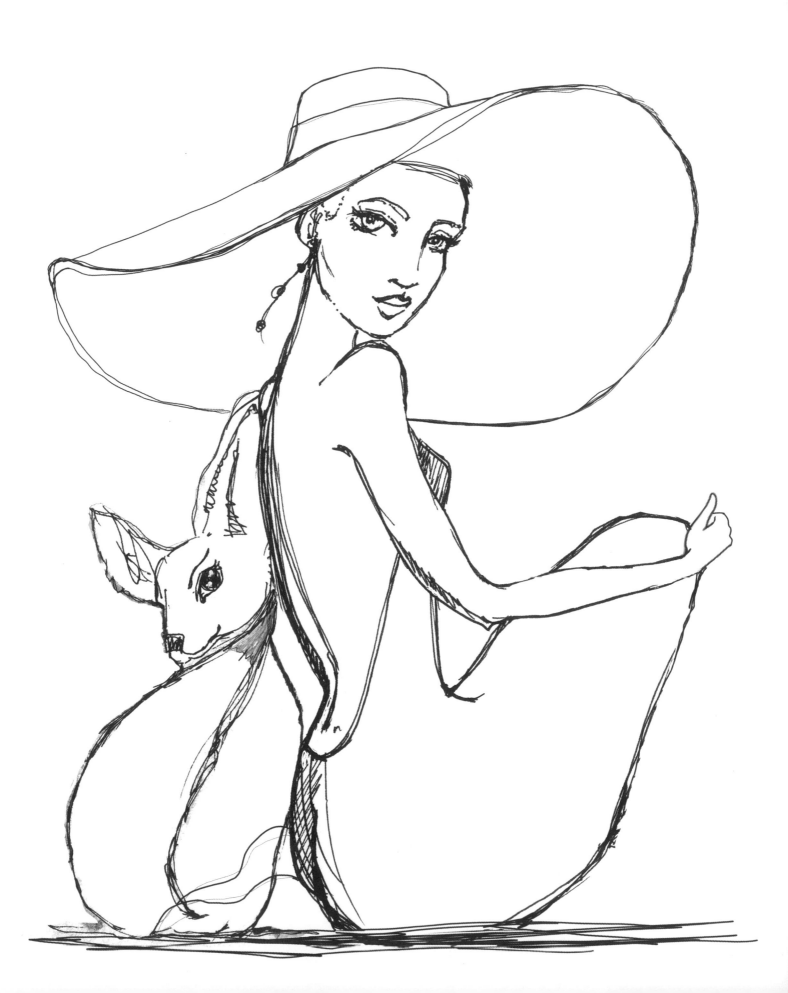

unexpected
friendships
are the best ones.

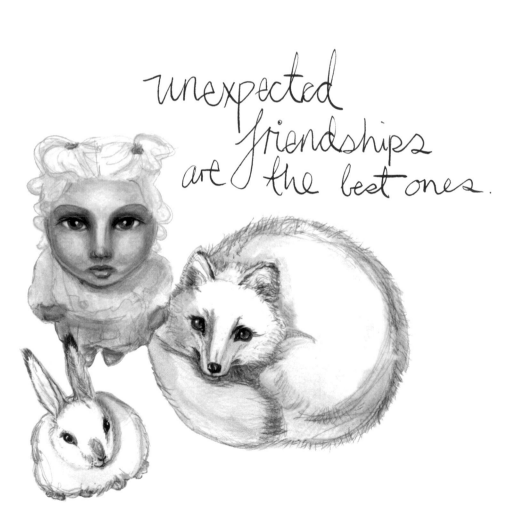

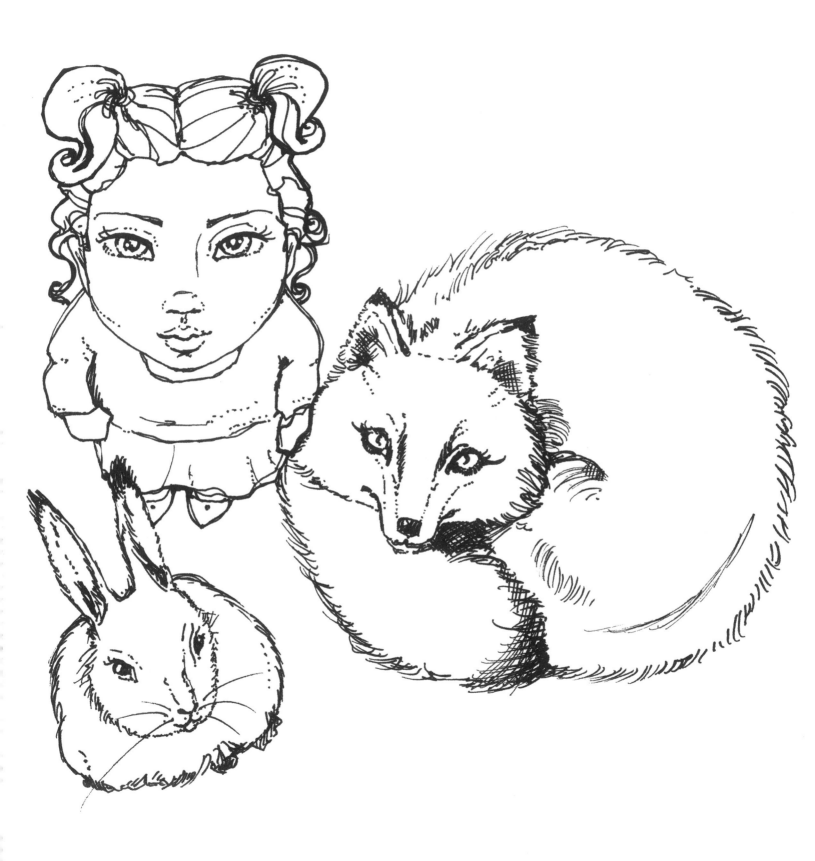

if the ocean can
calm itself,
so can you.

We are both salt water
mixed with air.

Nayyirah Waheed

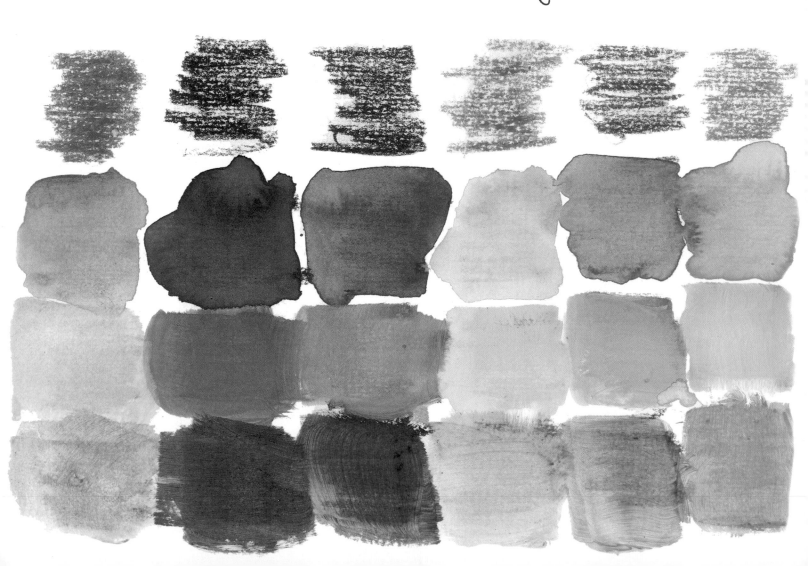

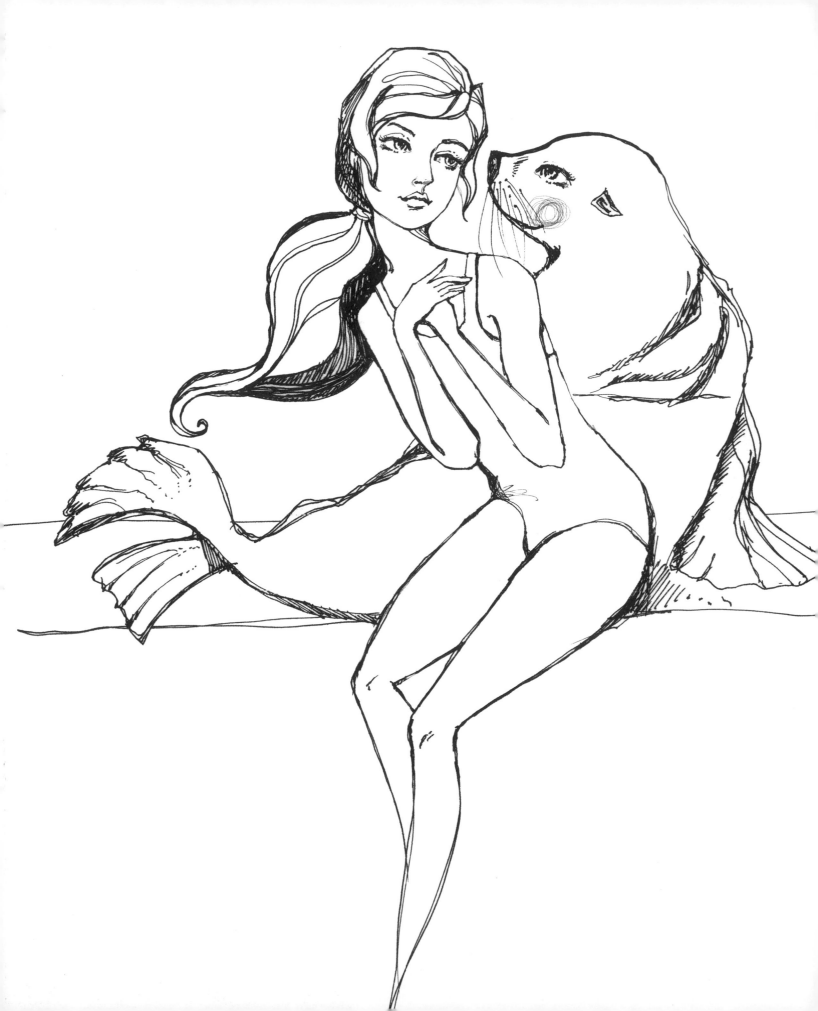

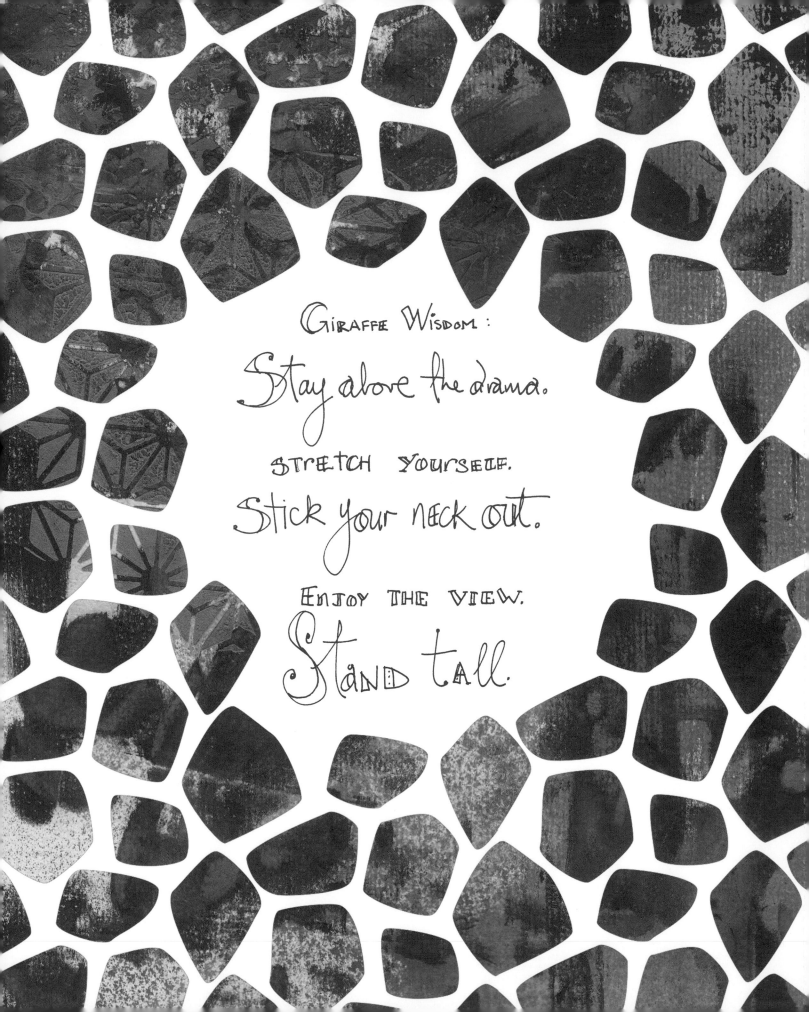

Giraffe Wisdom:

Stay above the drama.

stretch yourself.

Stick your neck out.

Enjoy the view.

Stand tall.

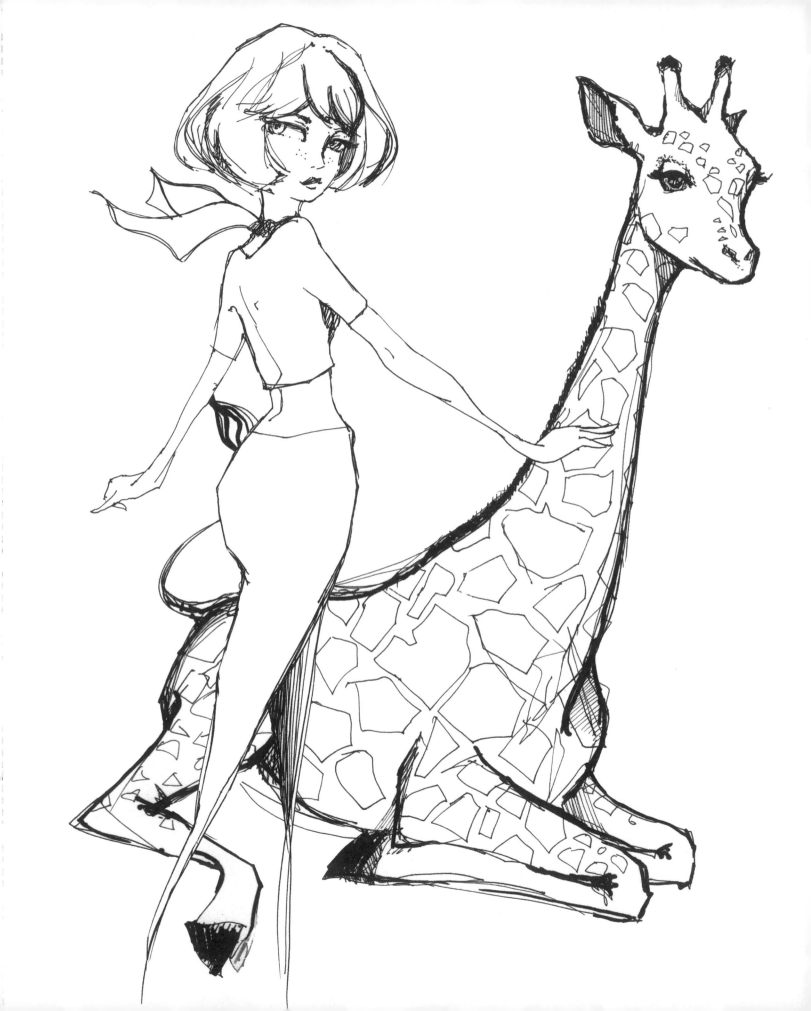

Protect
your
creativity.
BEFRIEND it.
It is your
strength in
Tough times.

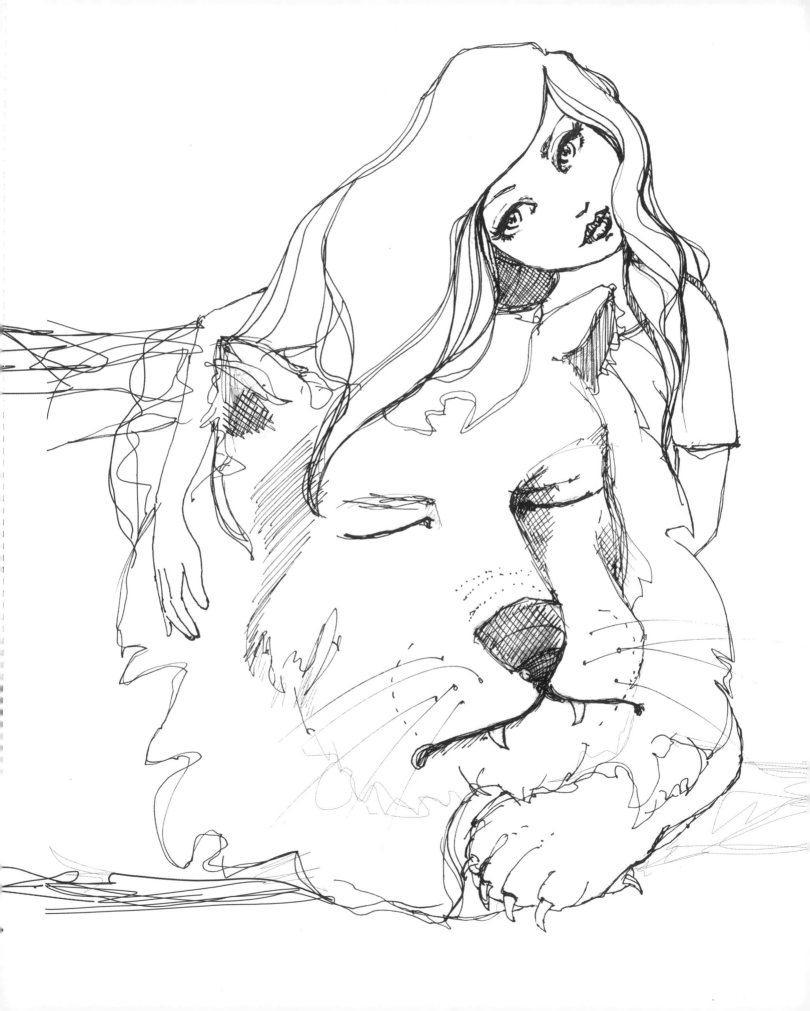

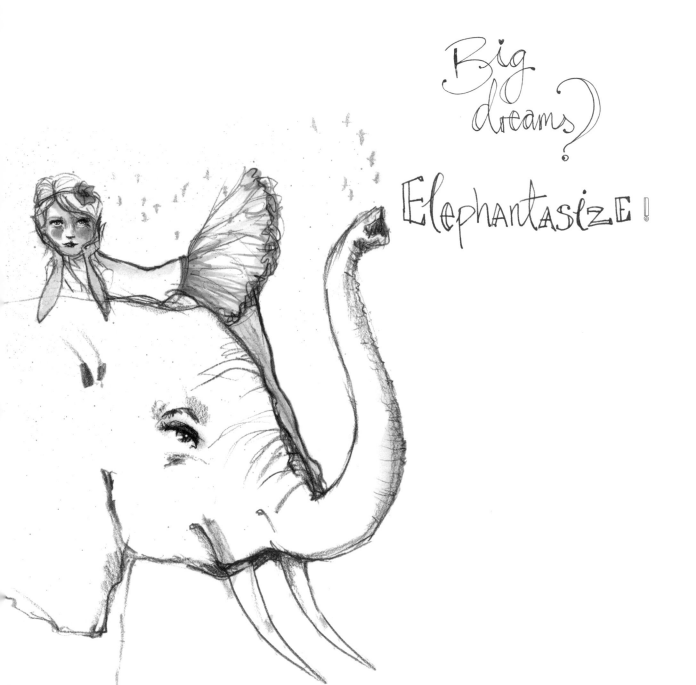

Big dreams?

Elephantasize!

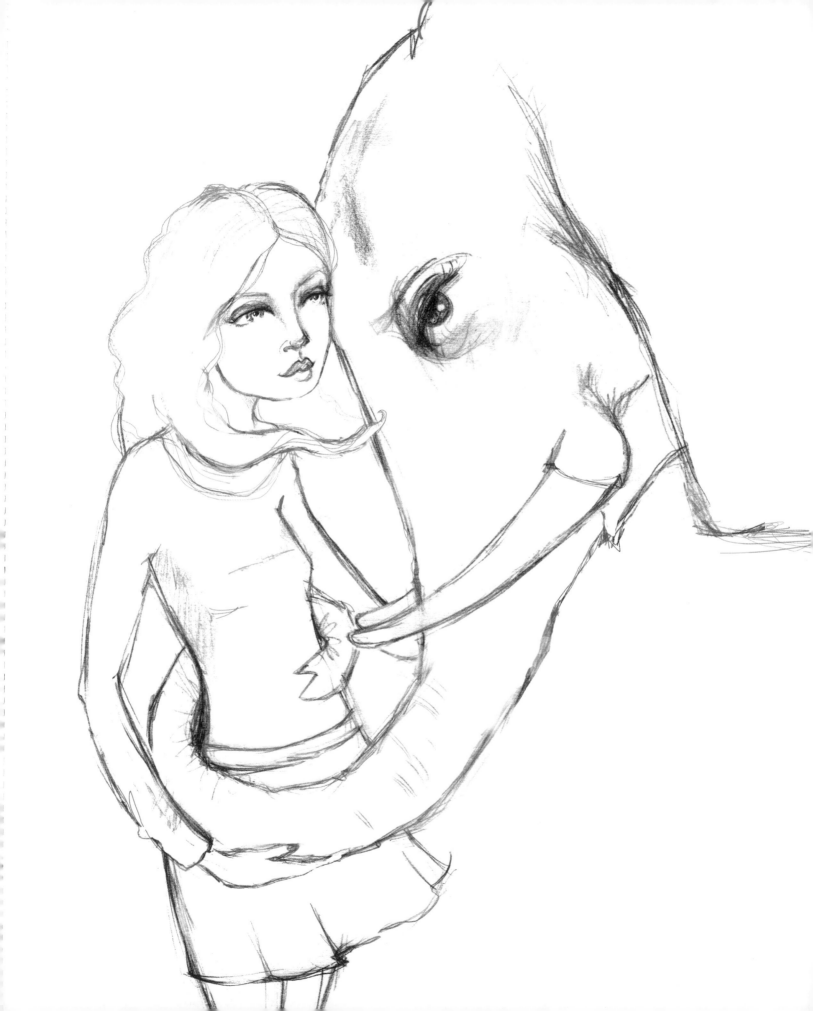

My best friend
is the one
who brings out
the best in me.

HENRY FORD

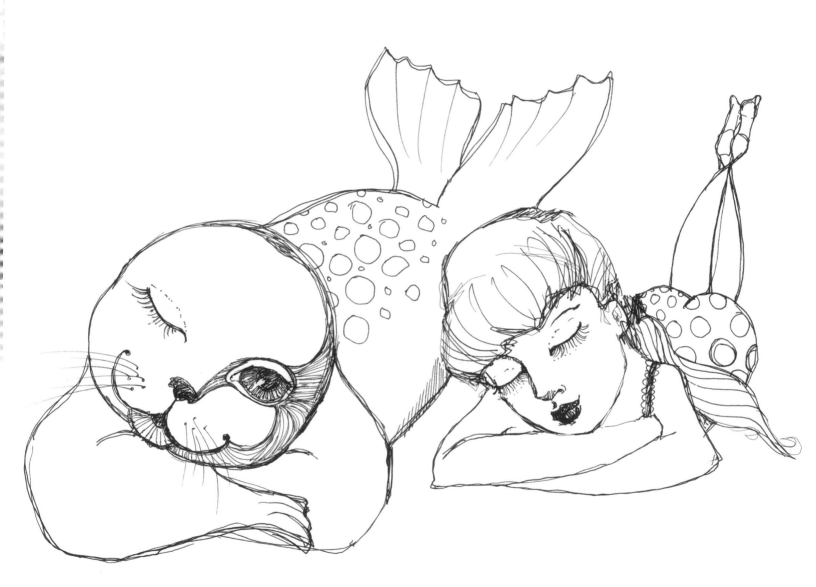

Creativity
can look
DANGEROUS
to people who
MAY NOT HAVE FELT
its embrace
in a while...

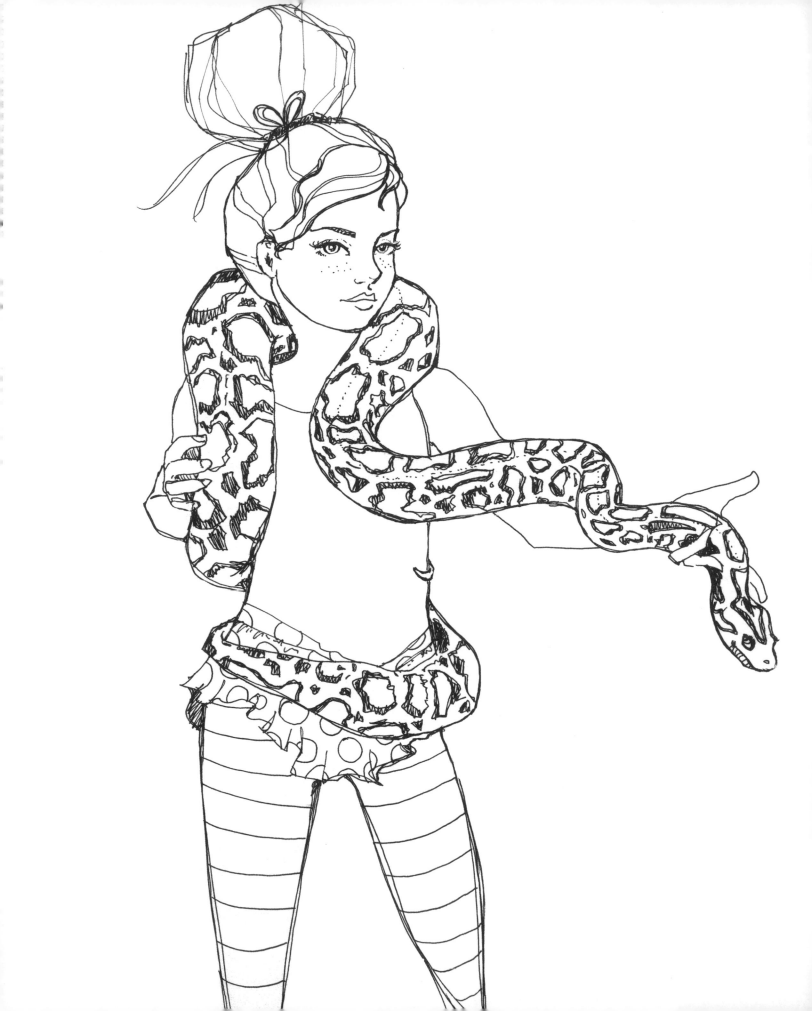

PENGUIN WISDOM:

Freeze out negativity.
Give anger the cold shoulder.
Take EVERY opportunity to chill.
stay frosty.

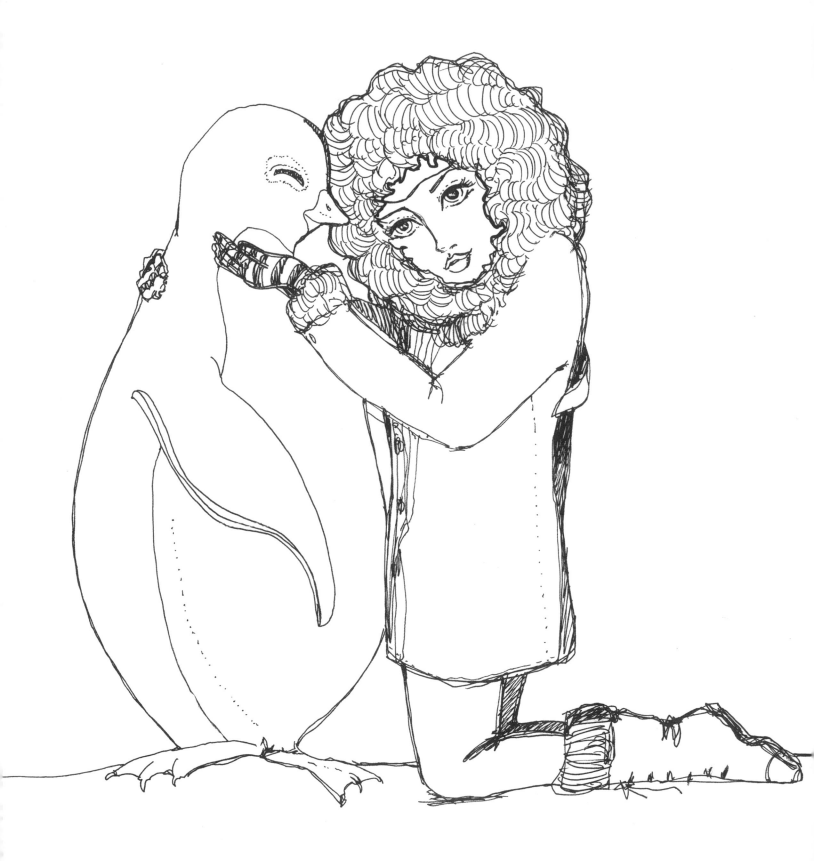

art, like morality,
consists of drawing
the line Somewhere

G.K. Chesterton

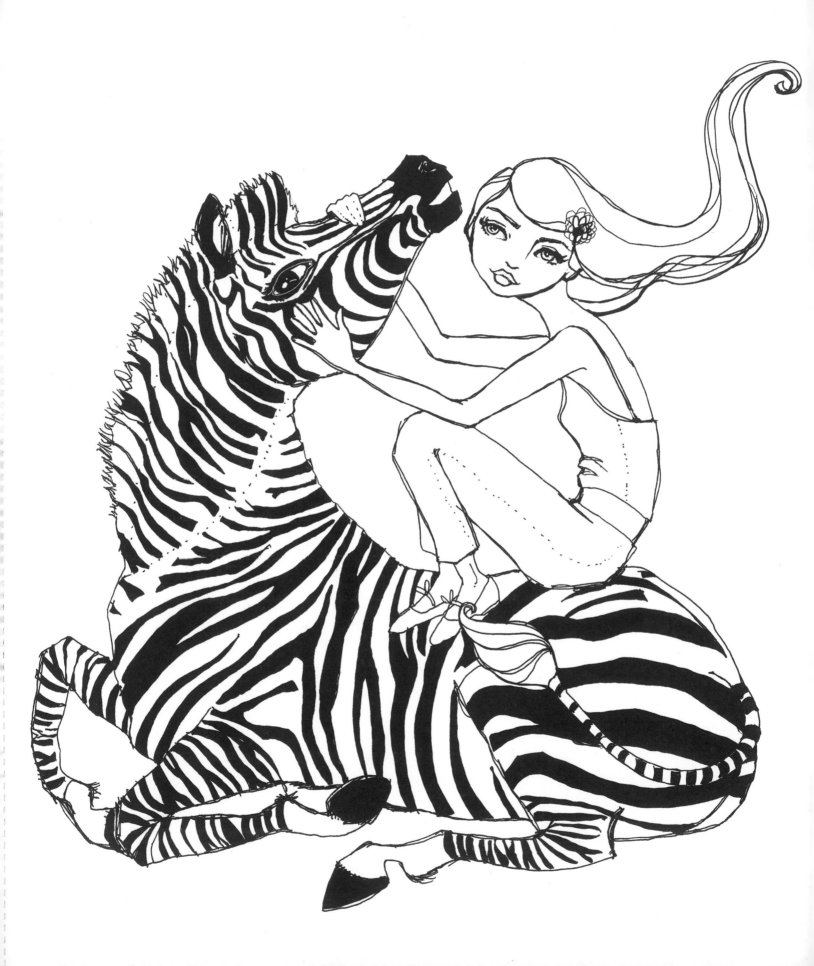

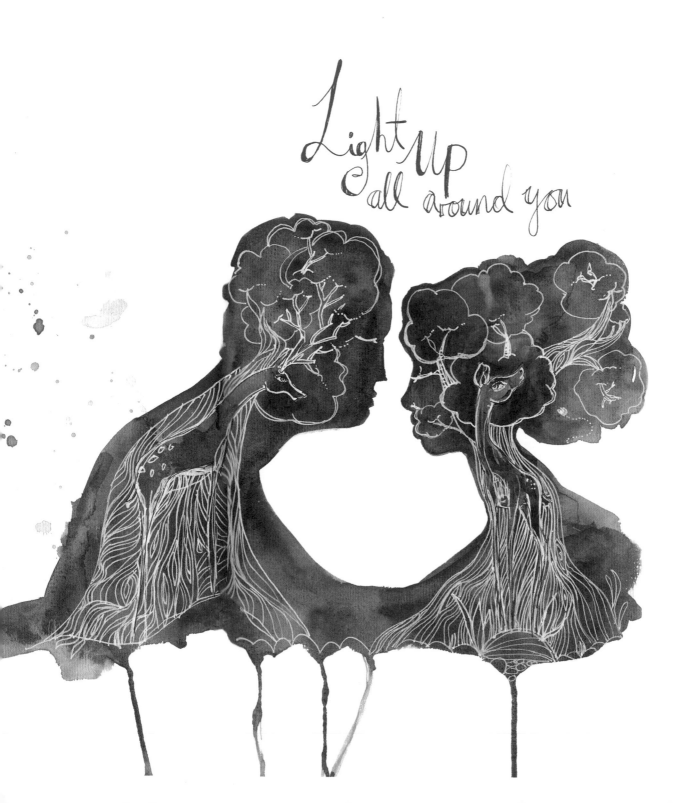

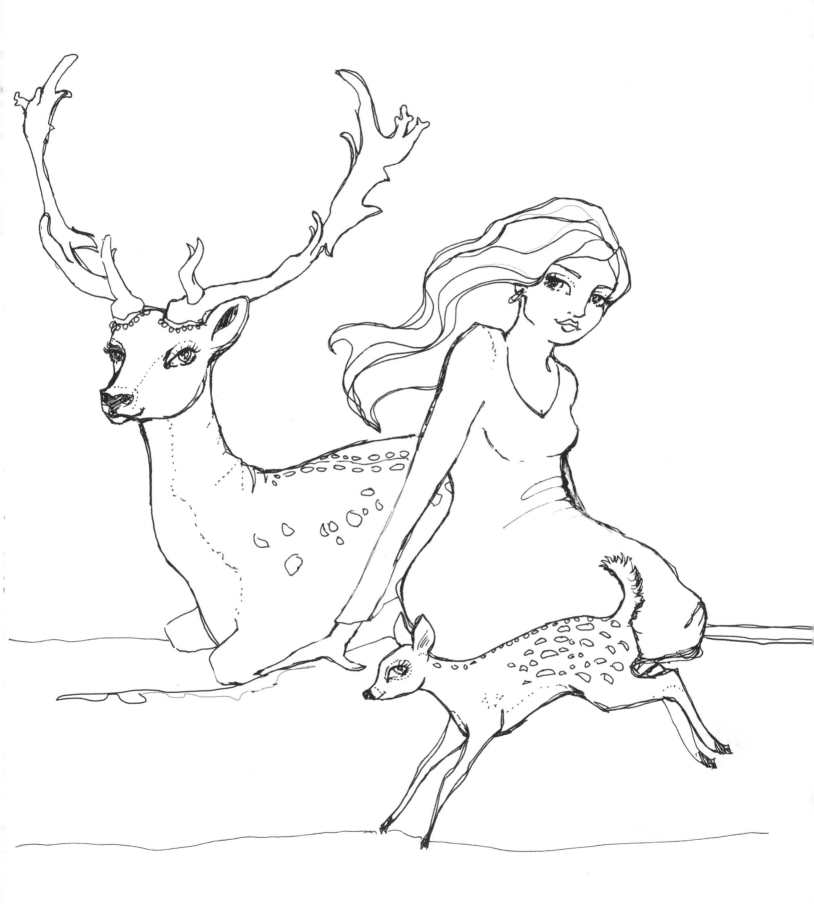

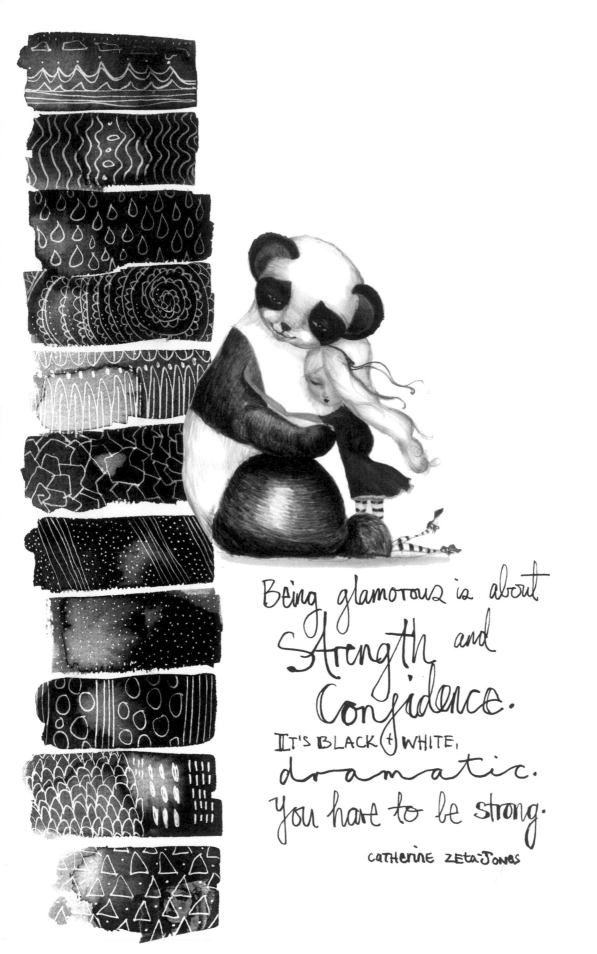

Being glamorous is about Strength and Confidence. IT'S BLACK & WHITE, dramatic. You have to be strong.

CATHERINE ZETA-JONES

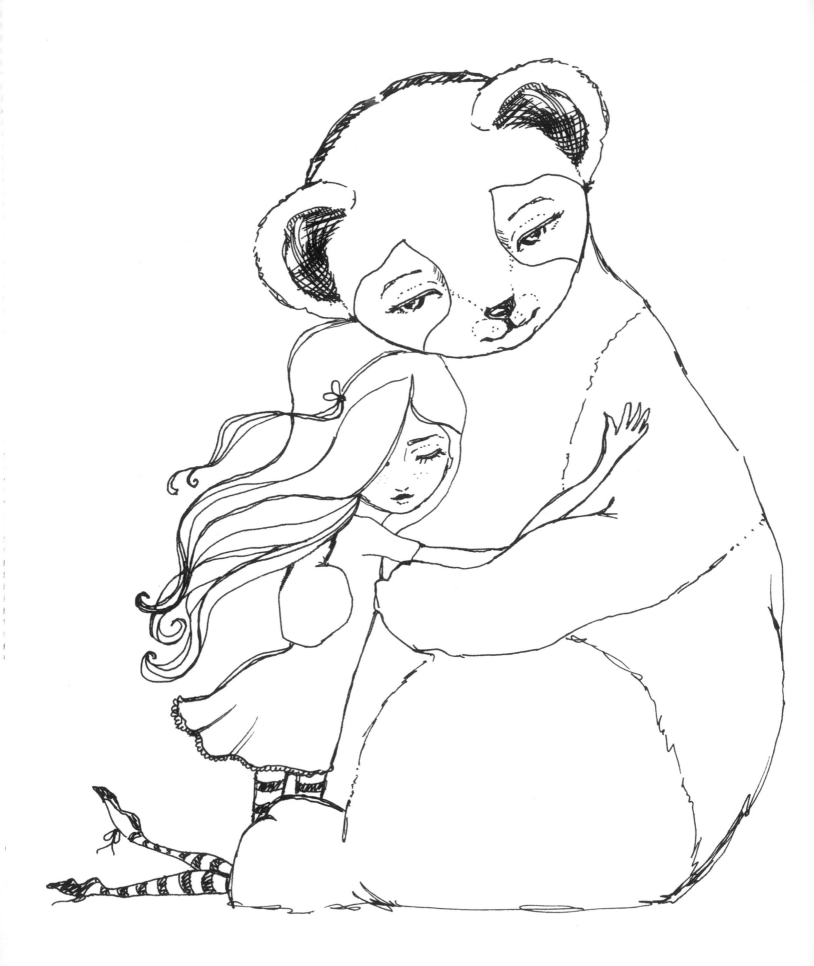

GATOR WISDOM:

Grow a thick skin.

Don't get snappy.

Lie in wait
and be patient.

Take care of your teeth.

SMILE

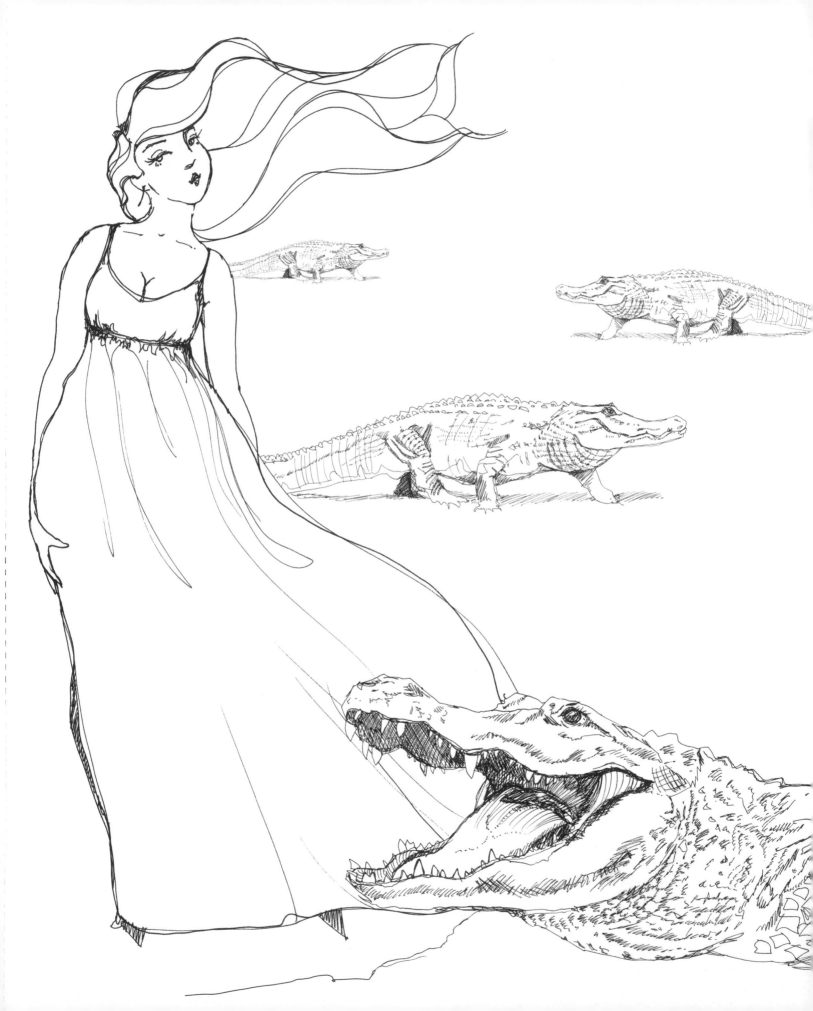

Keep the
drama
for your
Art ♡

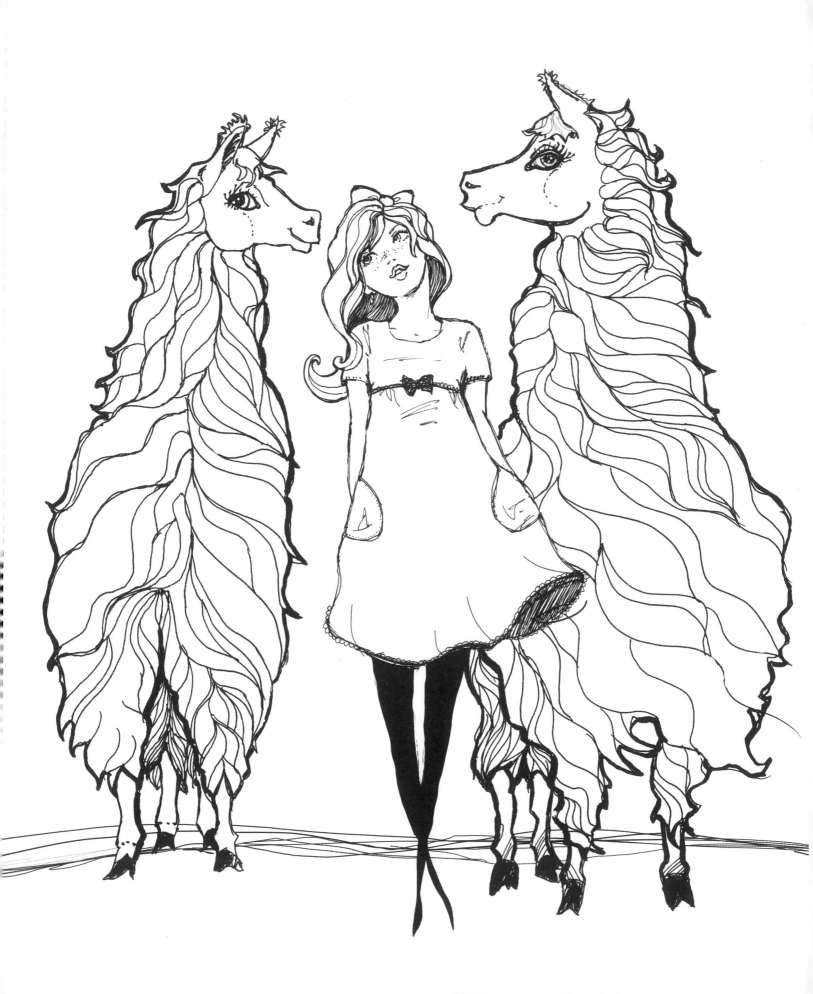

Art Supplies
are my very own
Creative
Menagerie

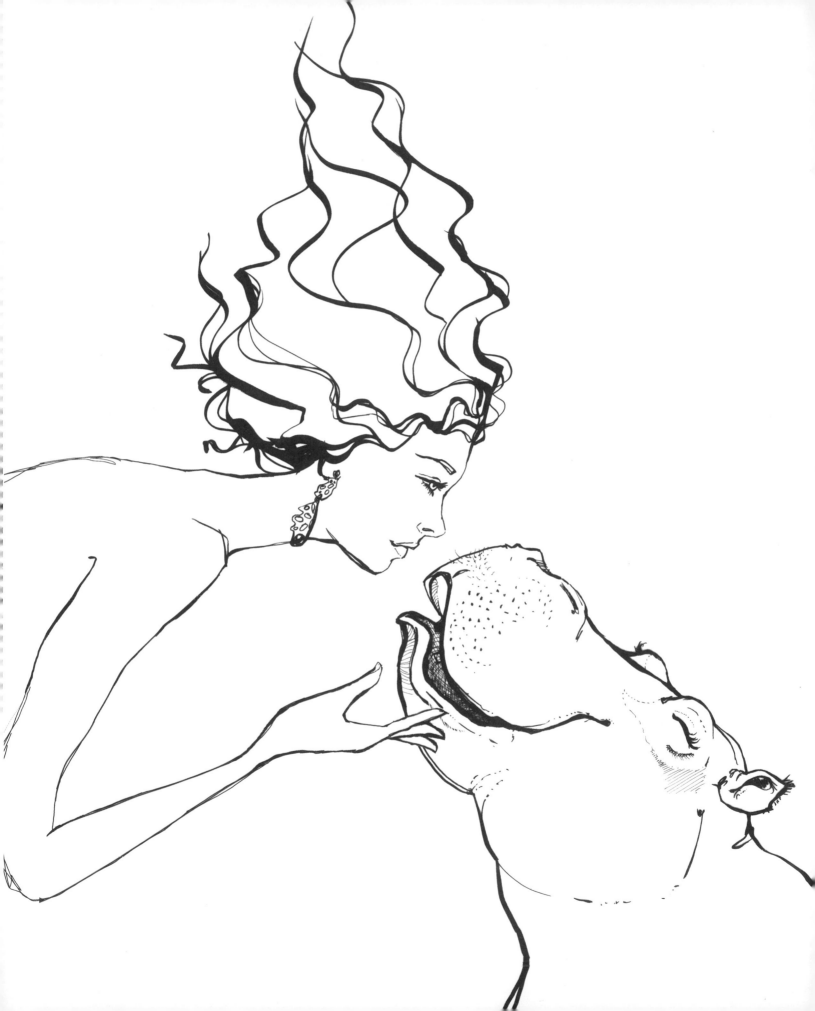

Take time to
be a little
silly,
to color
OUTSIDE THE
lines + feel free!

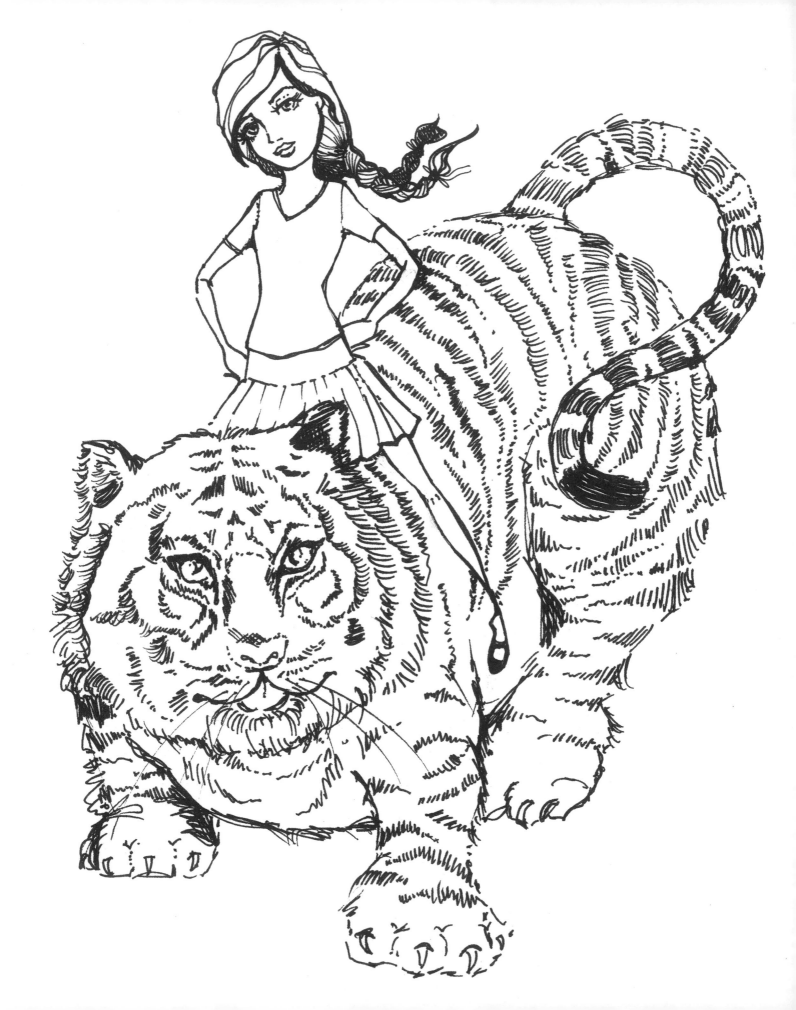

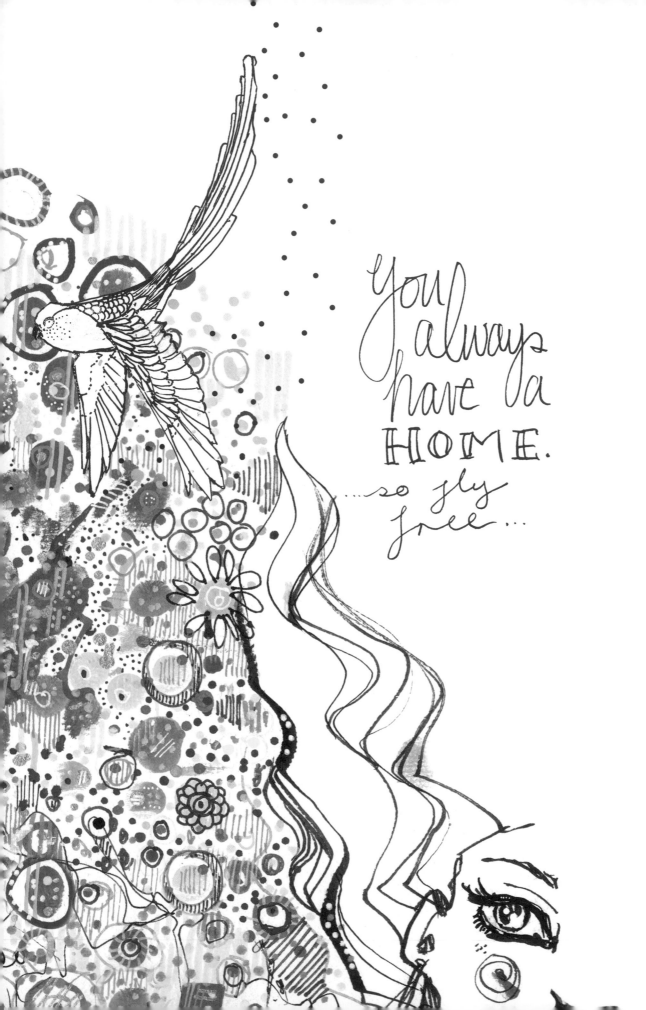

you always have a HOME. ...so fly free...

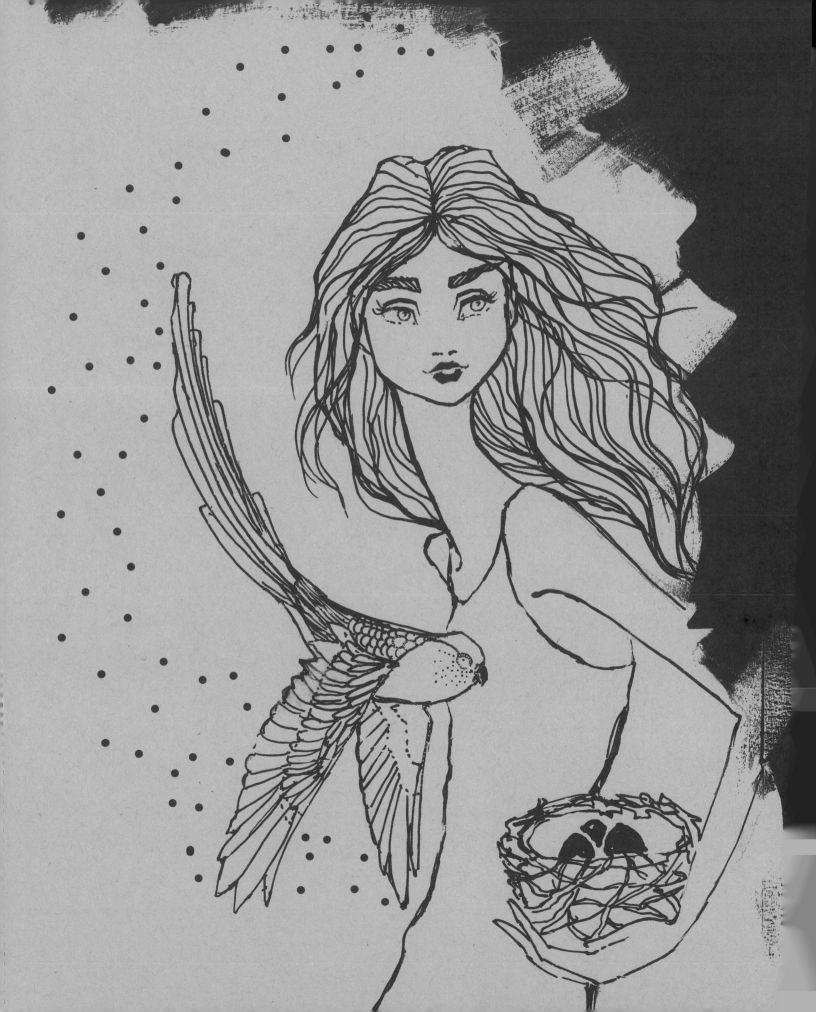

Watching an
artist
at work
is like seeing
a Magician
perform
their magic.

(SO LET PEOPLE WATCH
YOU CREATE!)

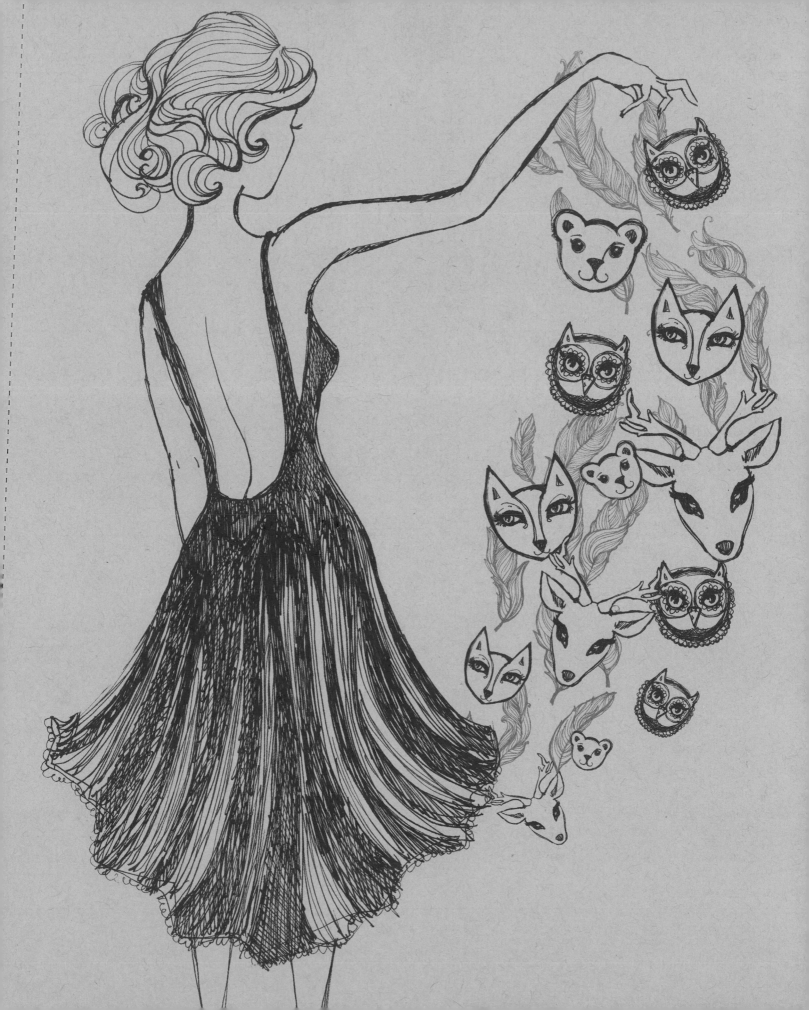

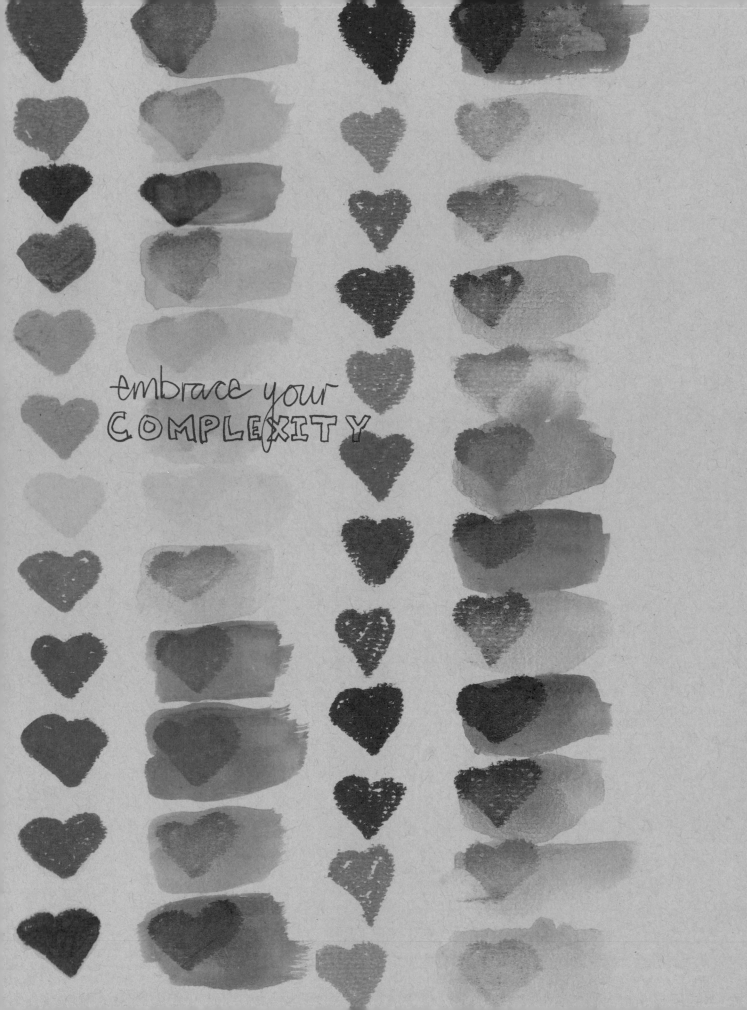

embrace your
COMPLEXITY

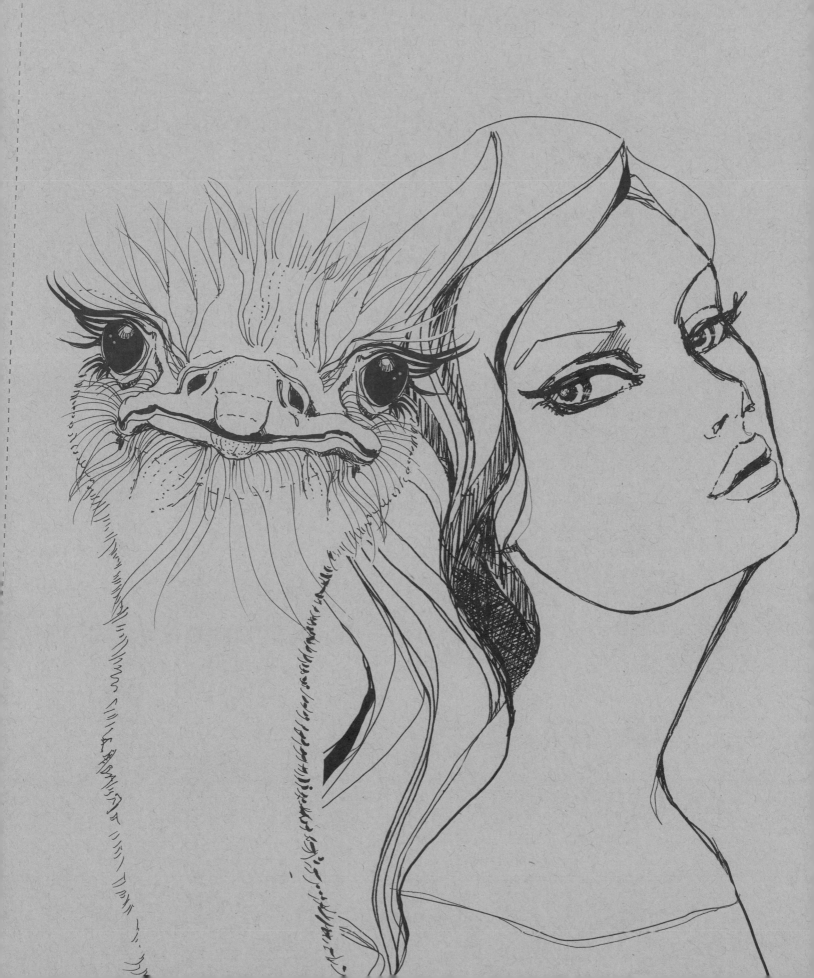

Roo WISDOM:

Let your heart skip!
HOP to it!
Jump for joy;
Leap INTO
Love.

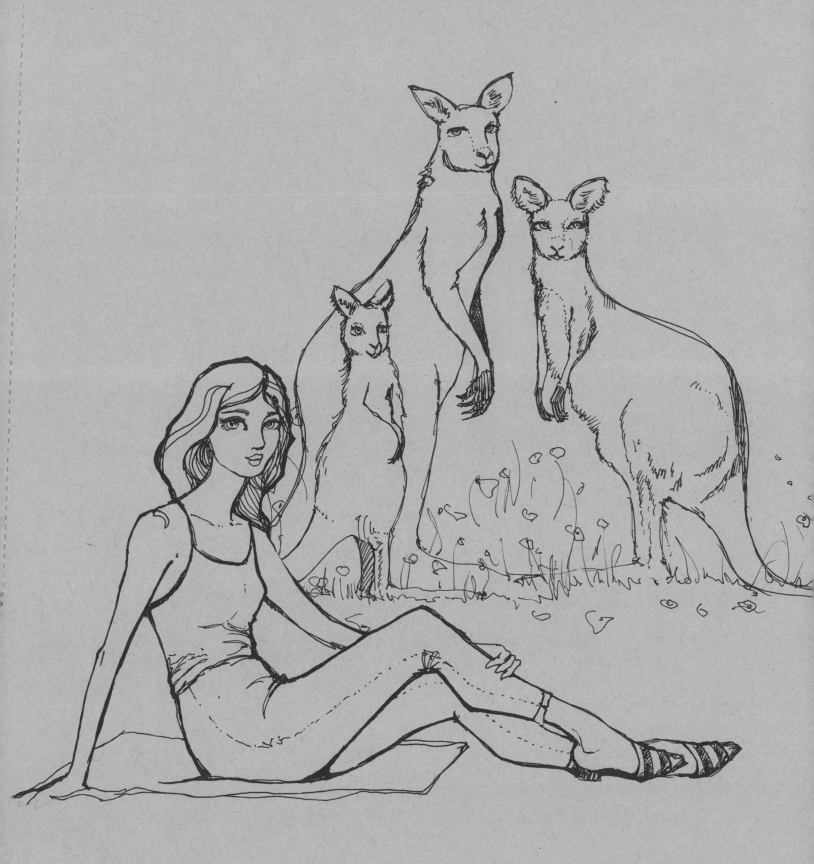

feeling
Prickly?

rather than feeling LOST,

let yourself
be found

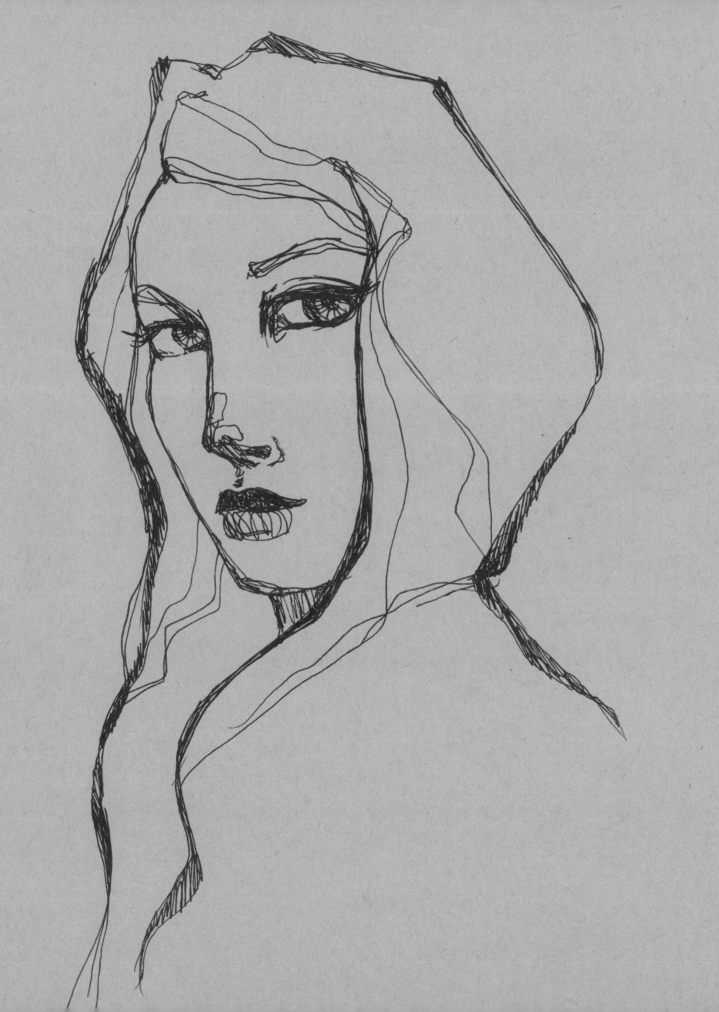

everyone needs
a sidekick

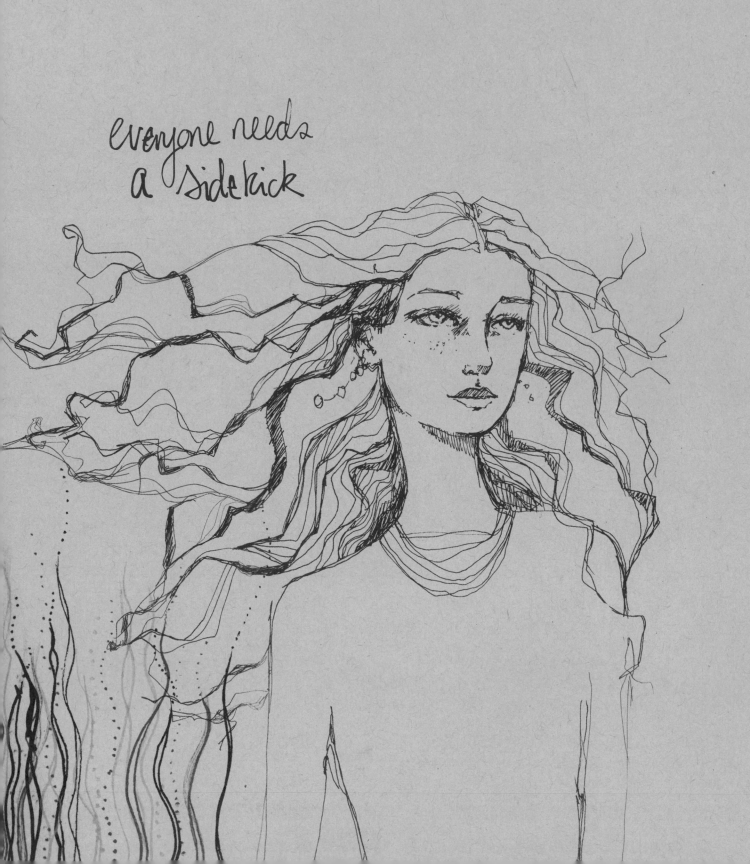

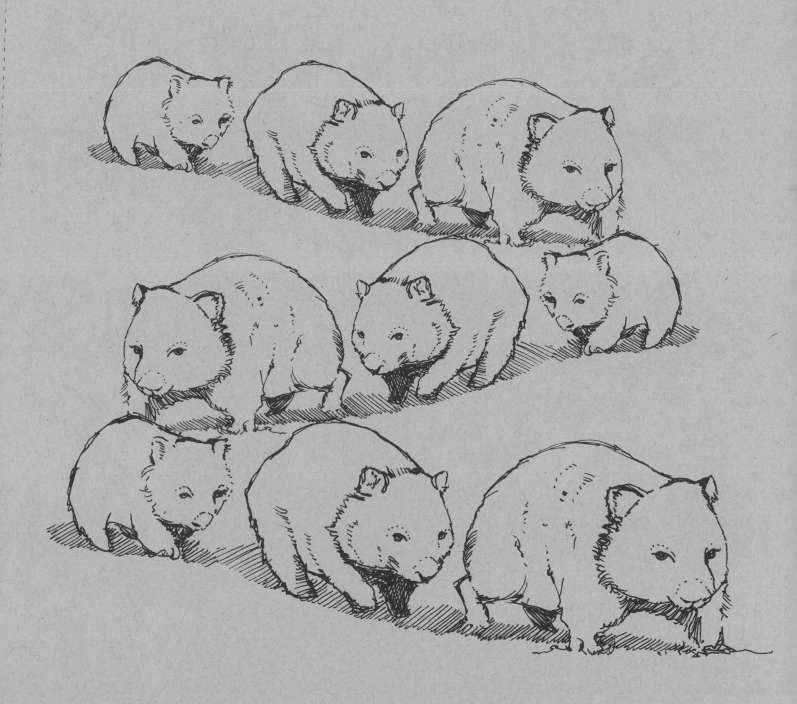

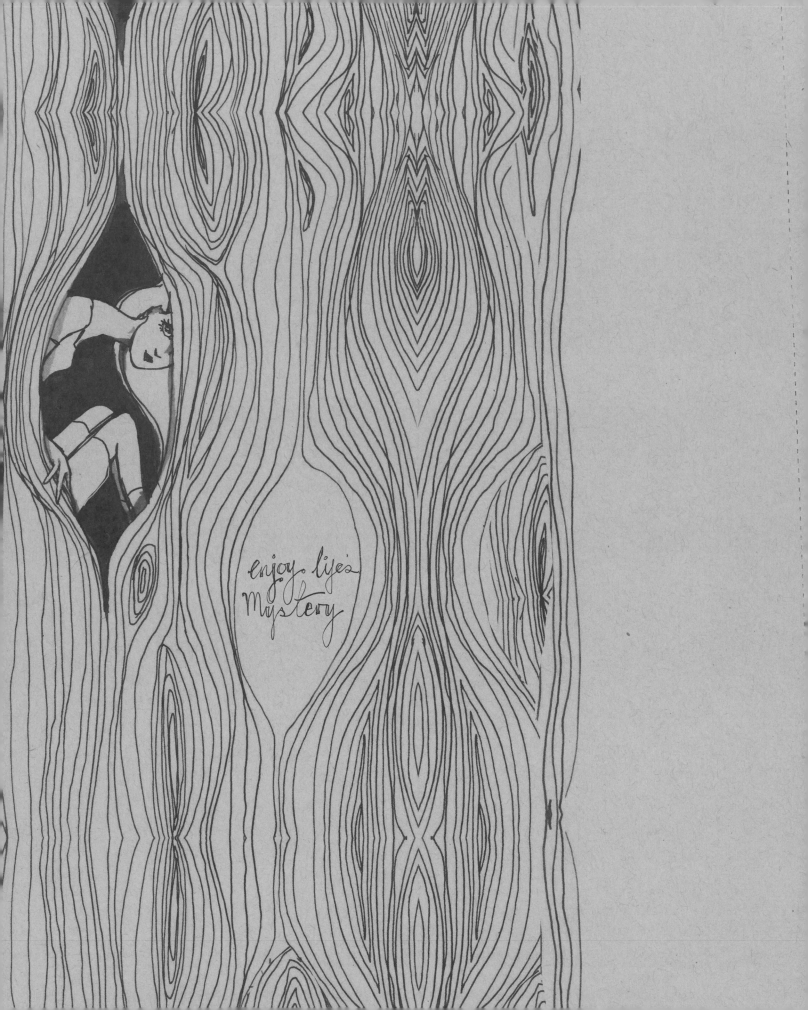

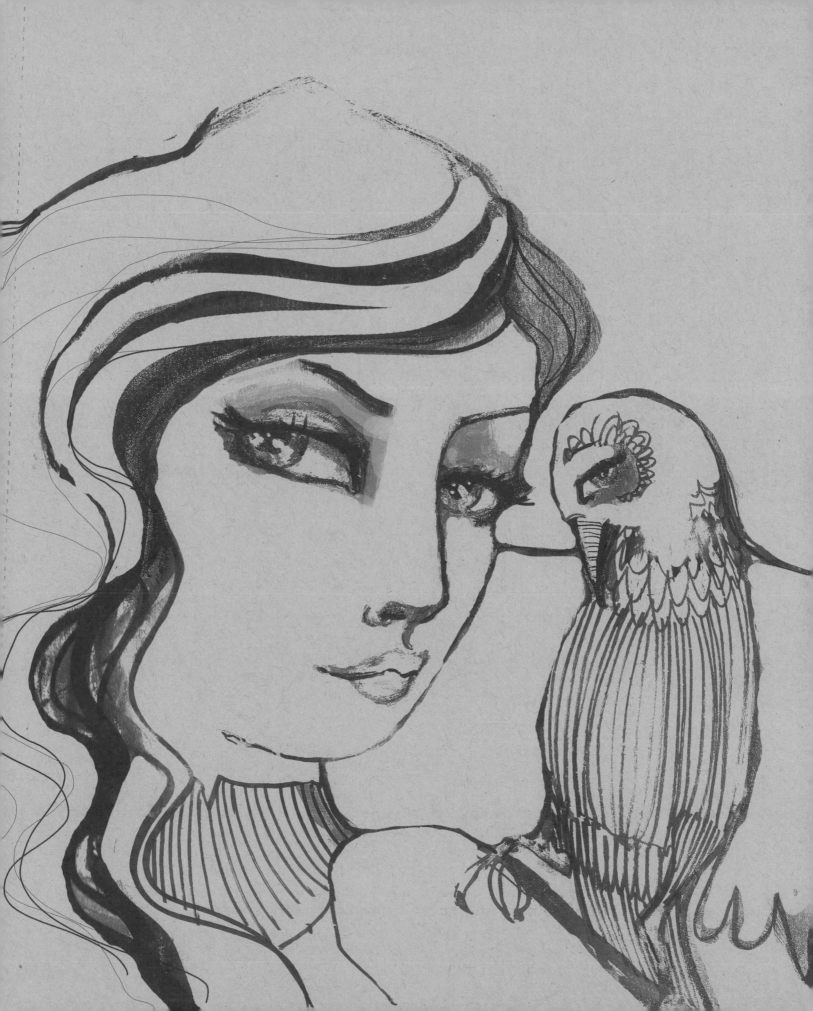

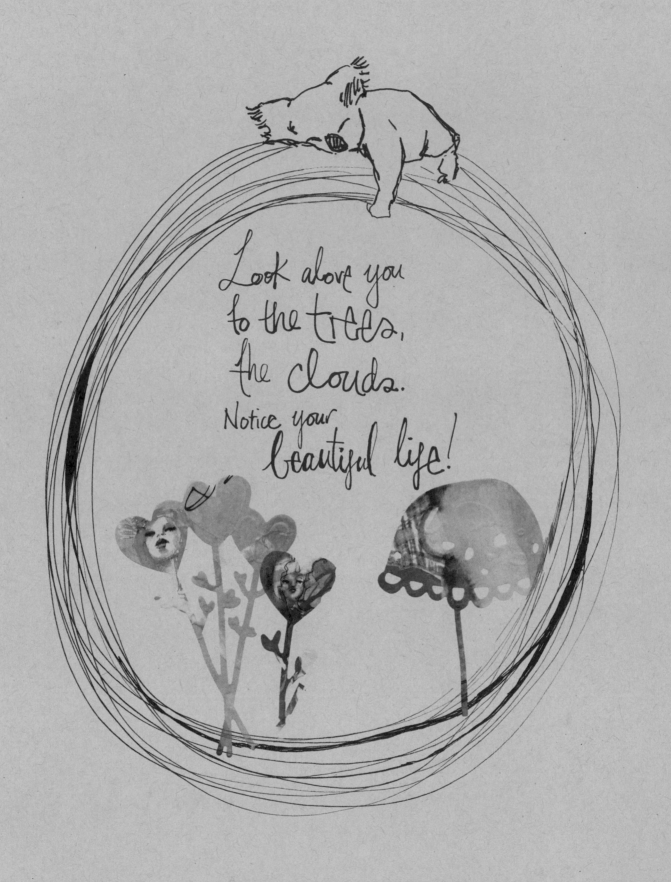

Look above you
to the trees,
the clouds.
Notice your
beautiful life!

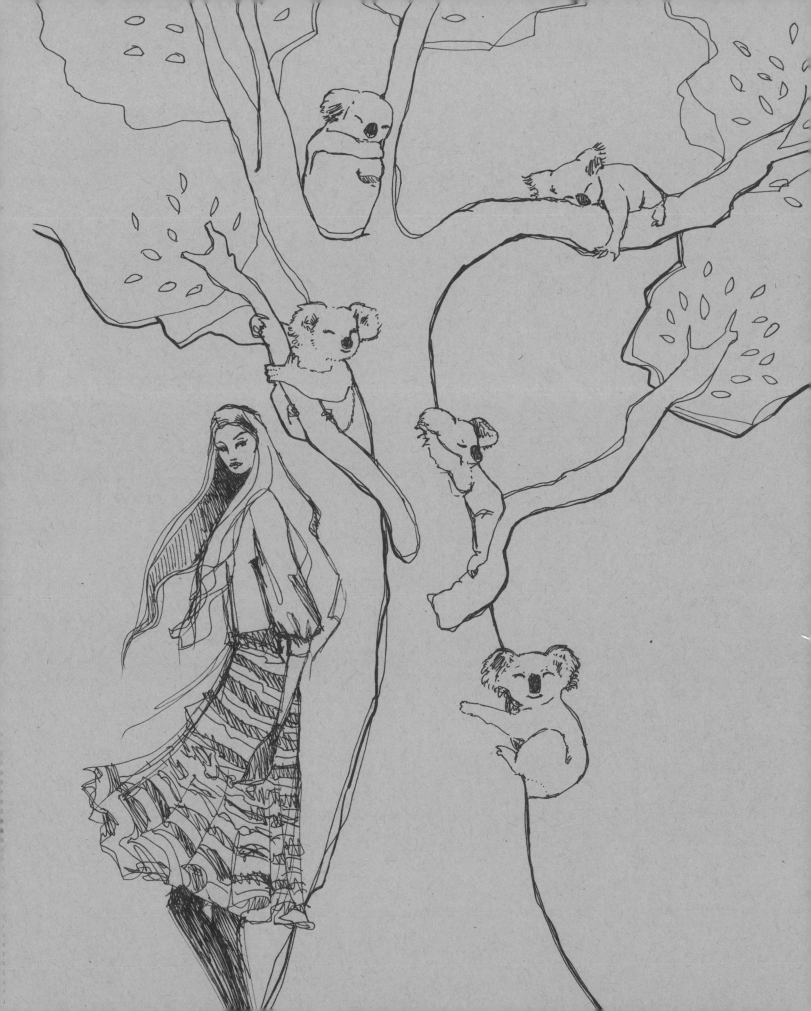

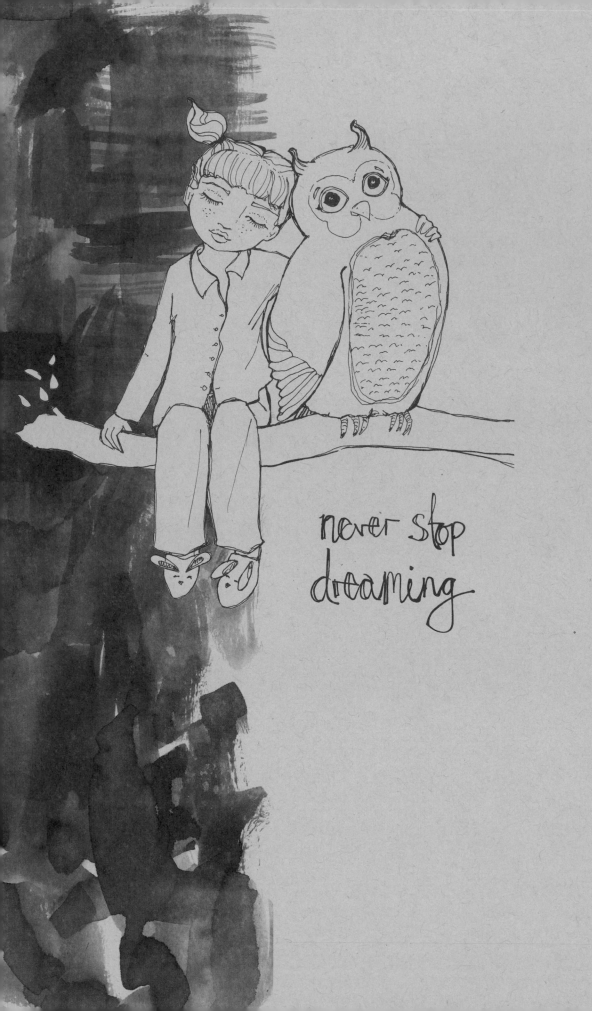

never stop
dreaming

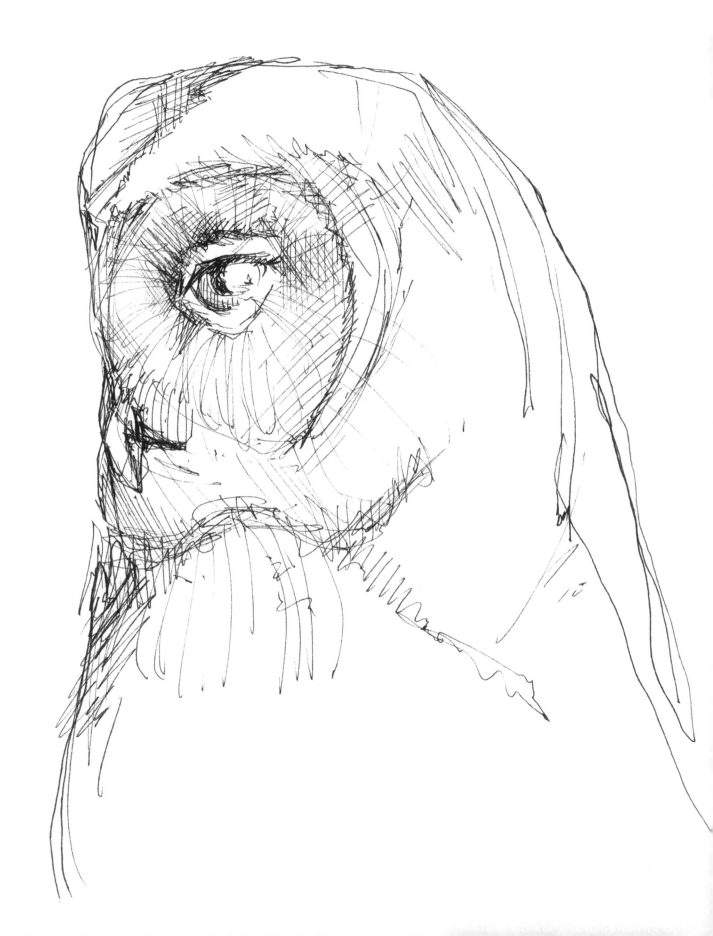

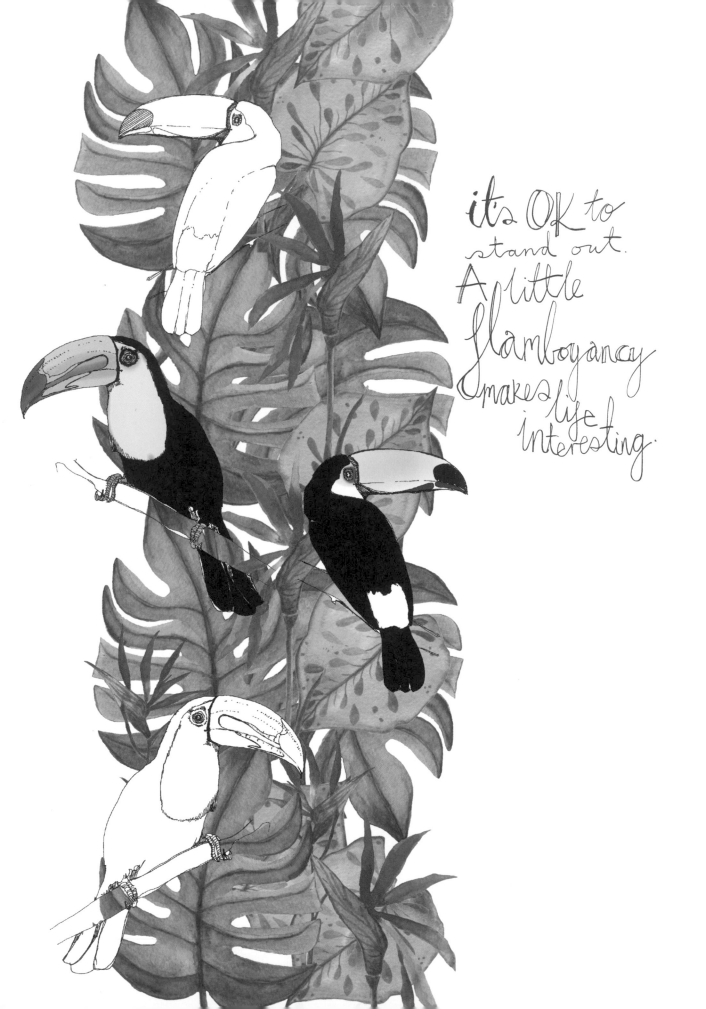

it's OK to stand out. A little flamboyancy makes life interesting.

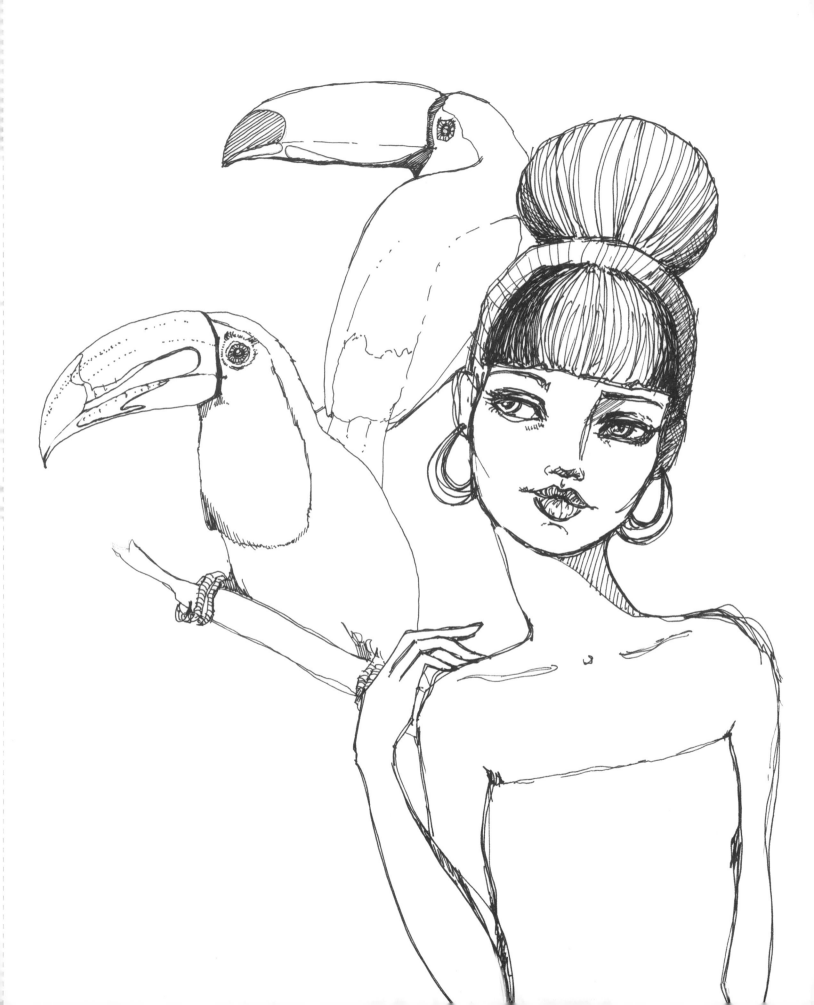

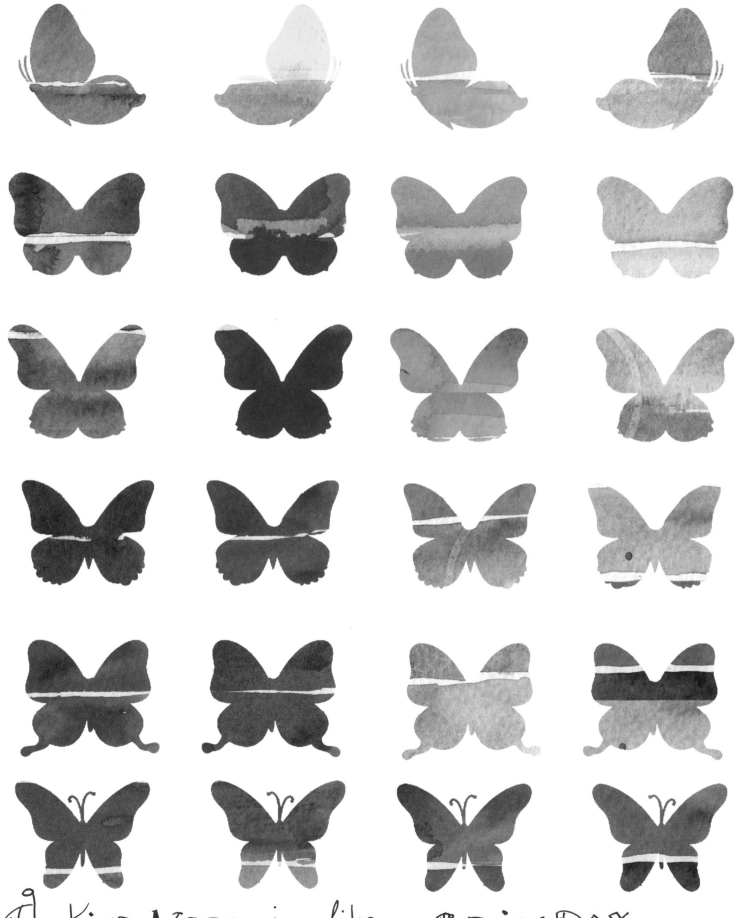

A KIND WORD is like a SPRING DAY.

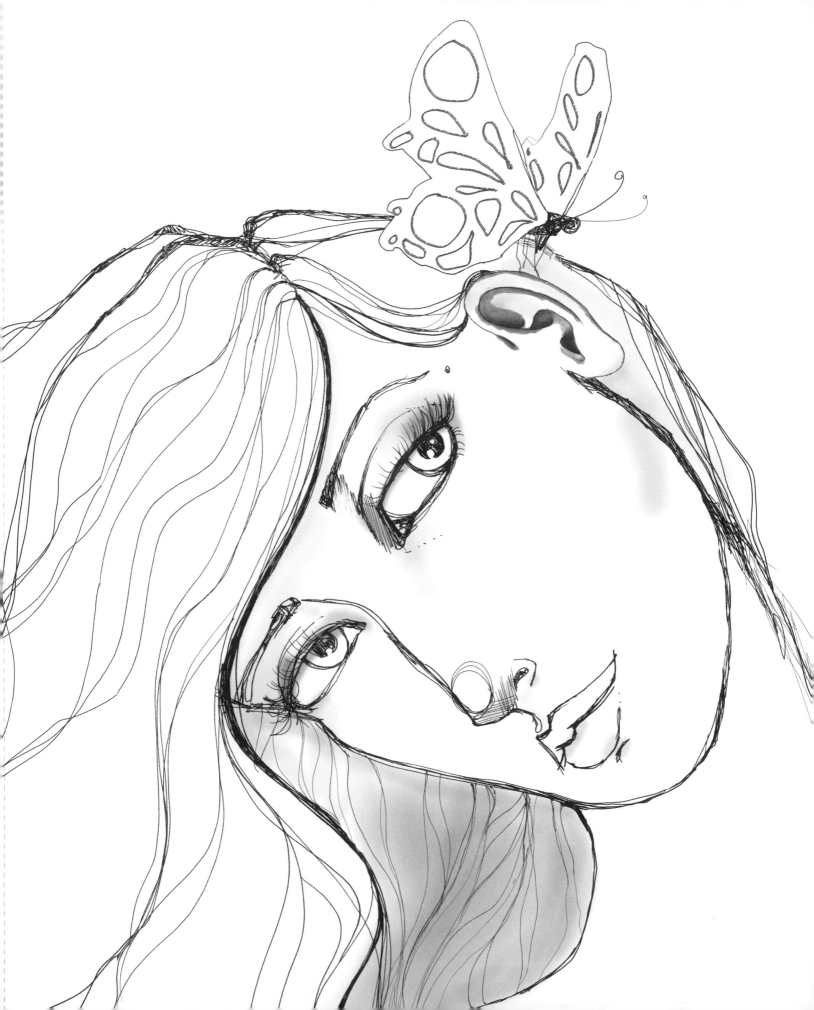

...erry	...lake	...Red Purple	...Red
	14 Jaune brill 1	15 Jaune brill 2	16 yellow ochre
...eep	22 greenish yellow	23 olive	2.. ...t
...ambou	Compose green 2	51 Compose geen 1	2 Cobolt green
...arine	38 Manganese Blue Nova	39 Peacock	40 Compose blue
...ussian	...ndigo	...ynes	...eutral

Make your
own Rainbow

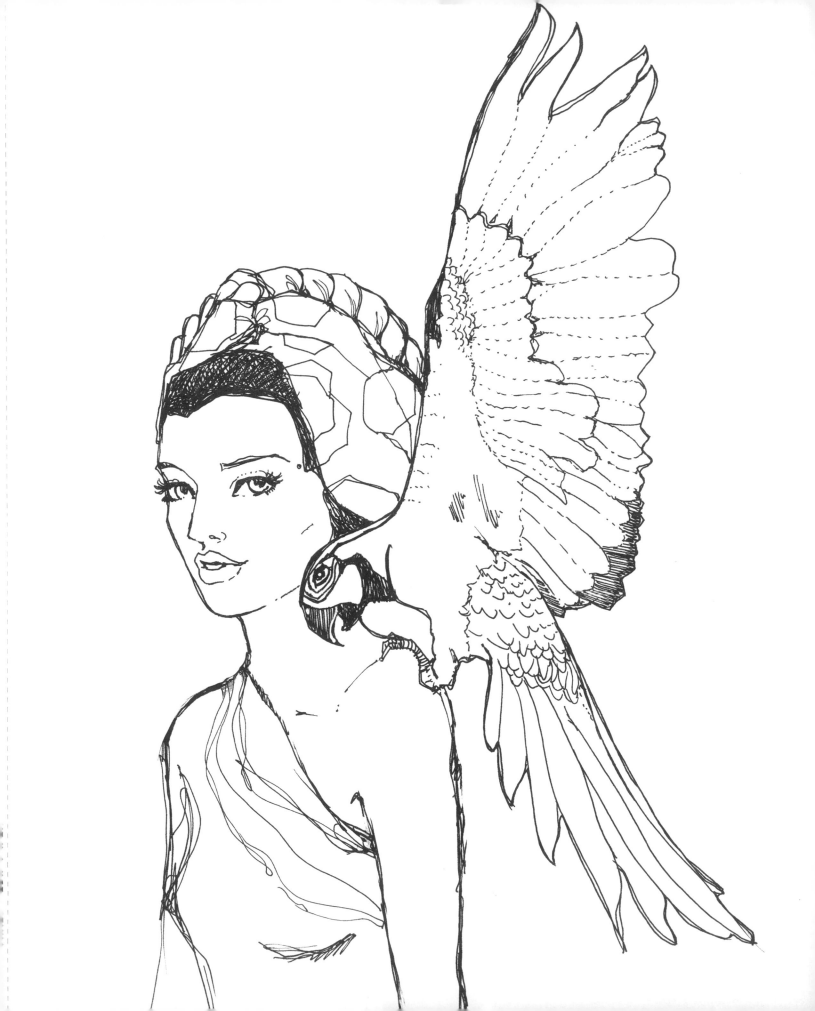

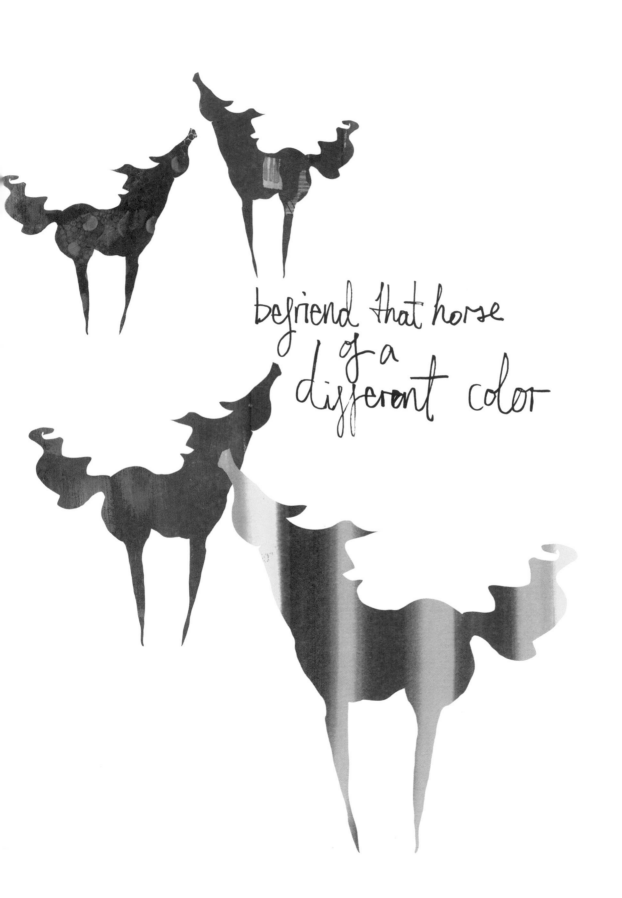

befriend that horse of a different color

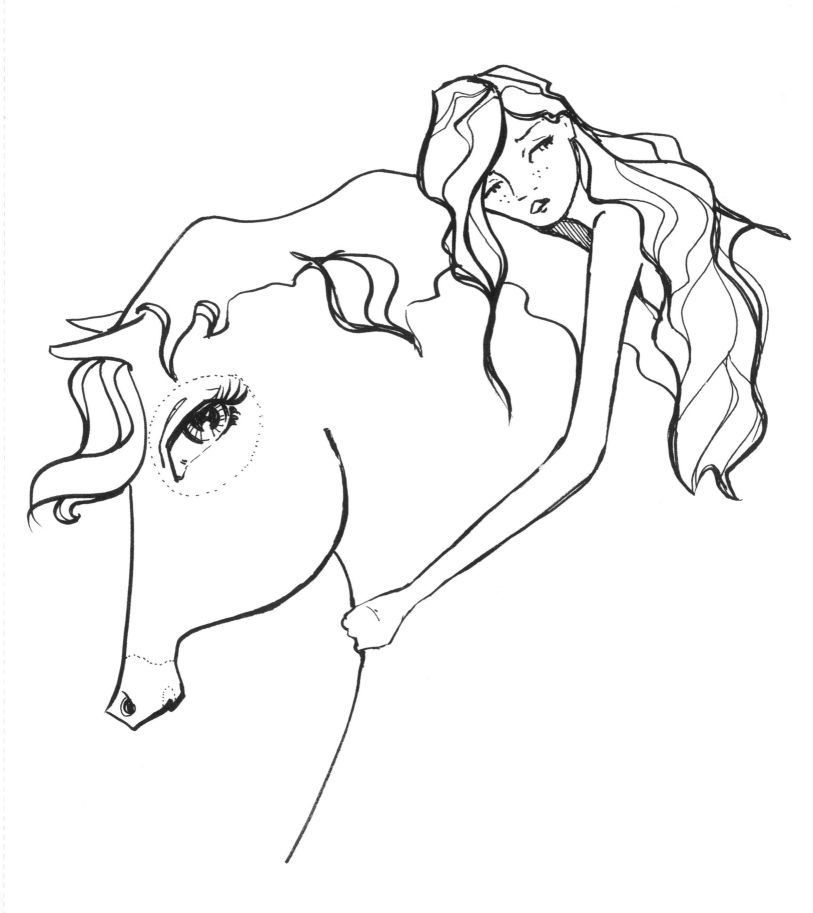

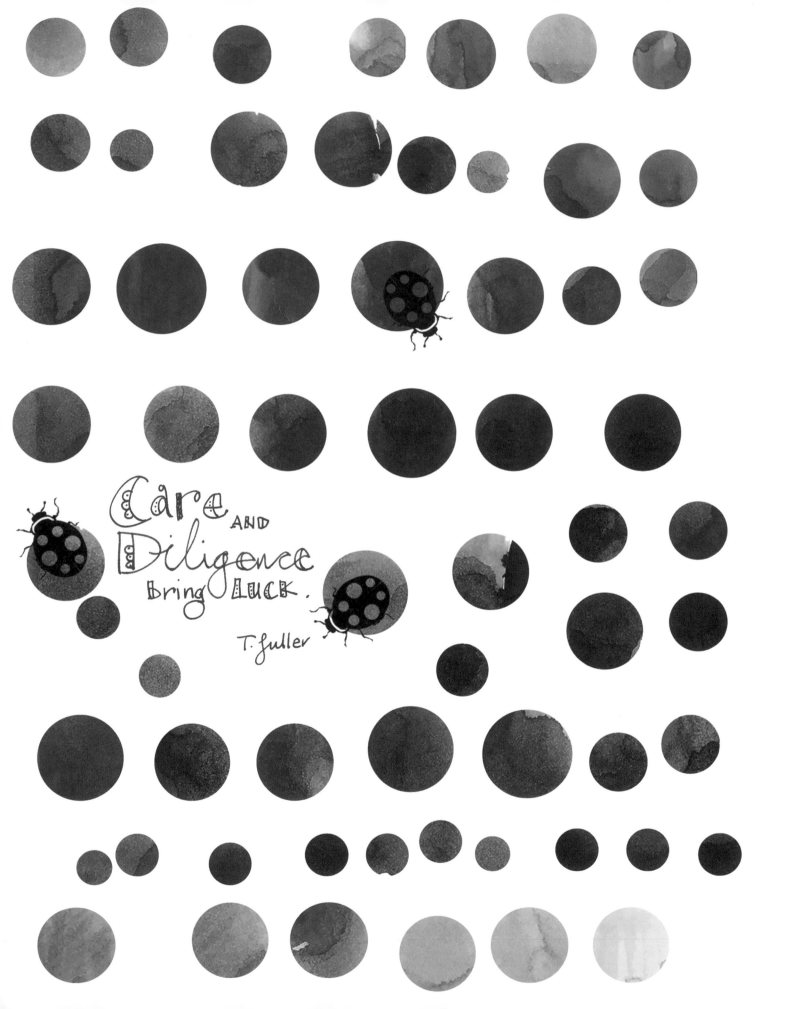

Care AND Diligence bring LUCK.

T. fuller

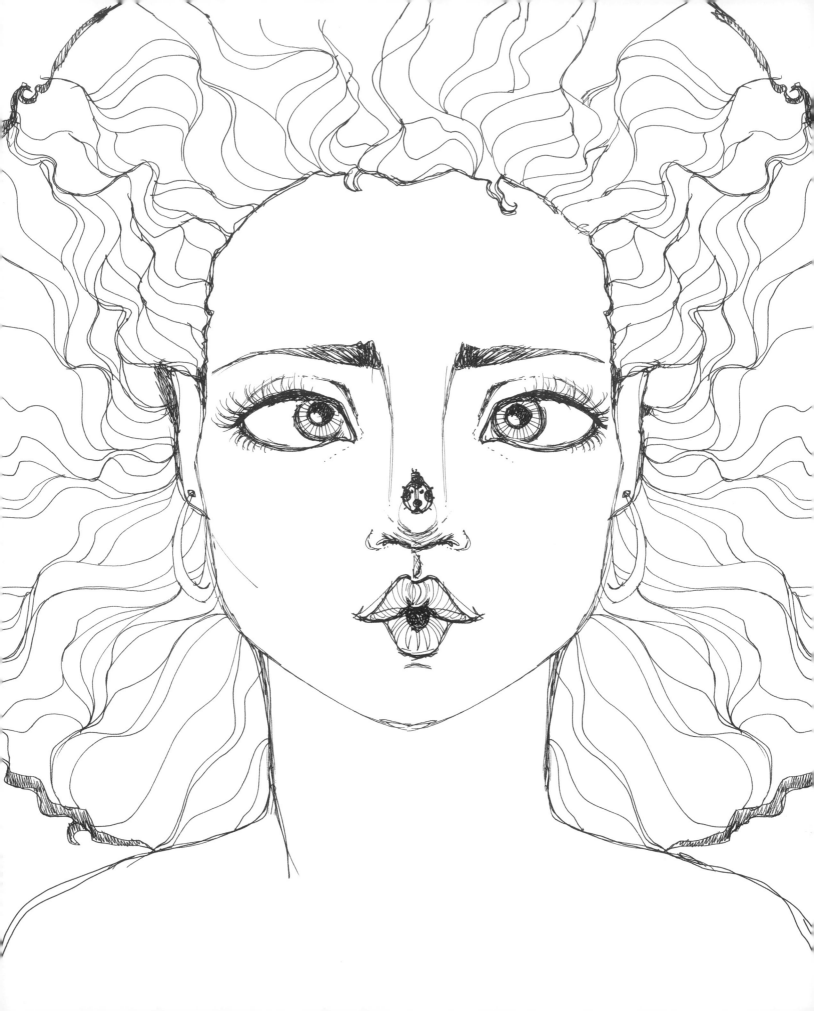

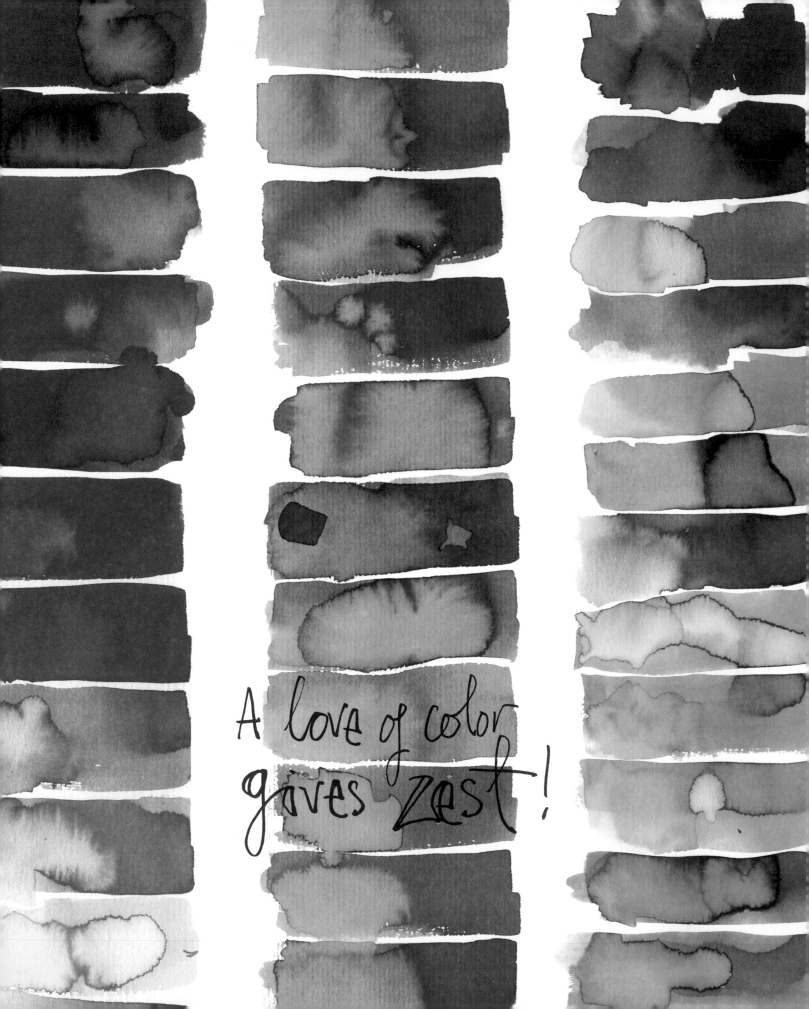

A love of color gives zest!

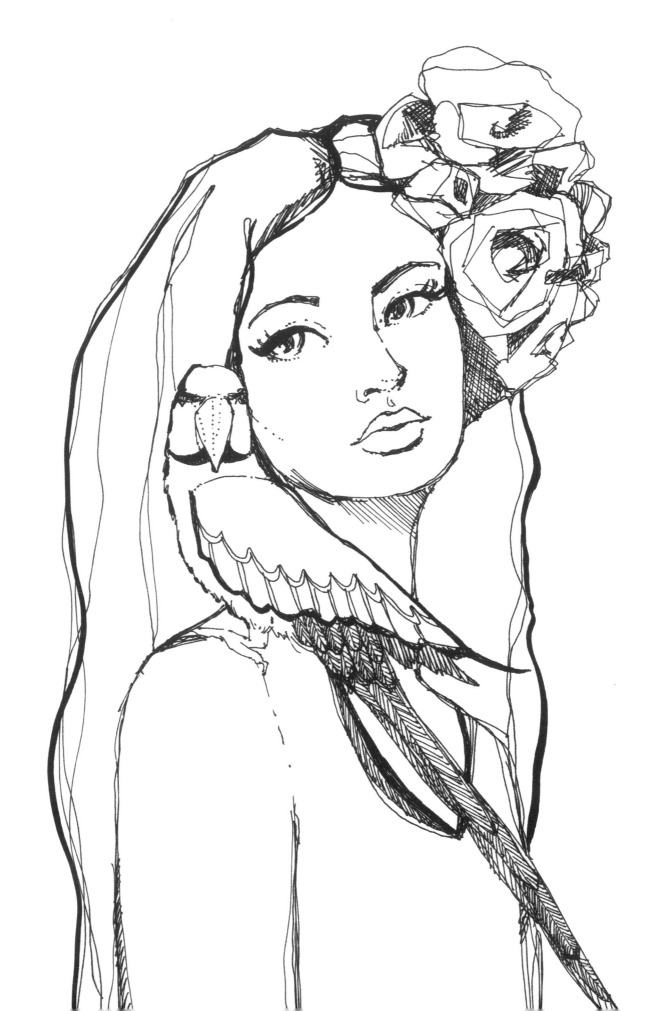

sway your hips, Dance and Dream

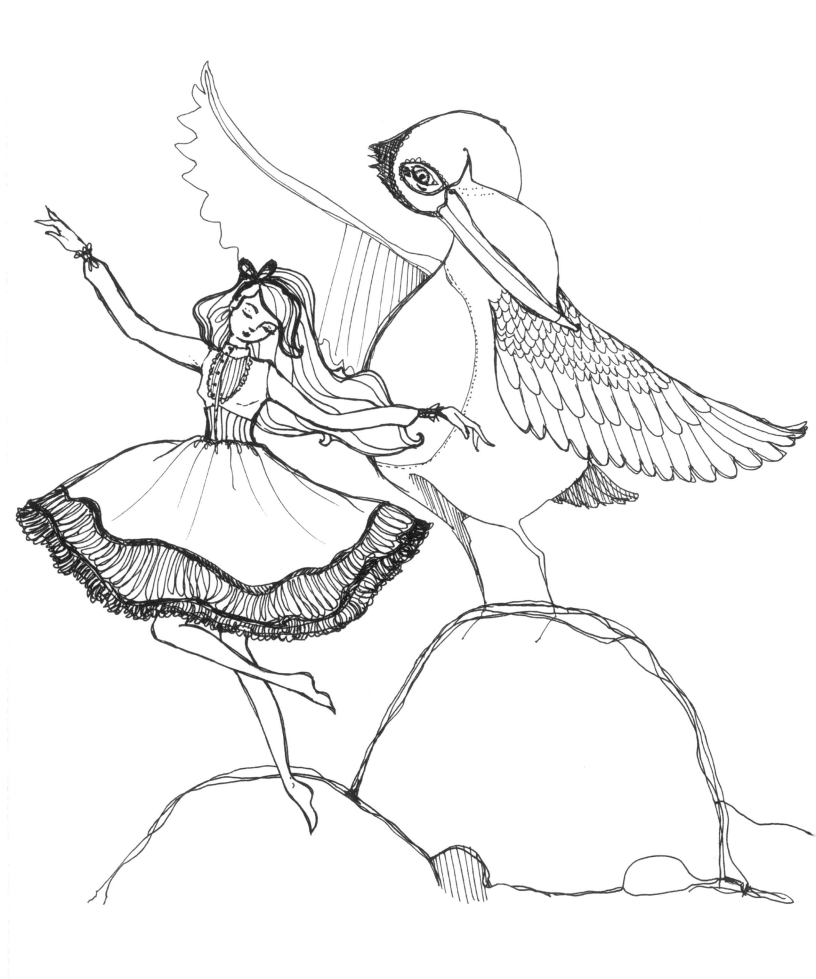

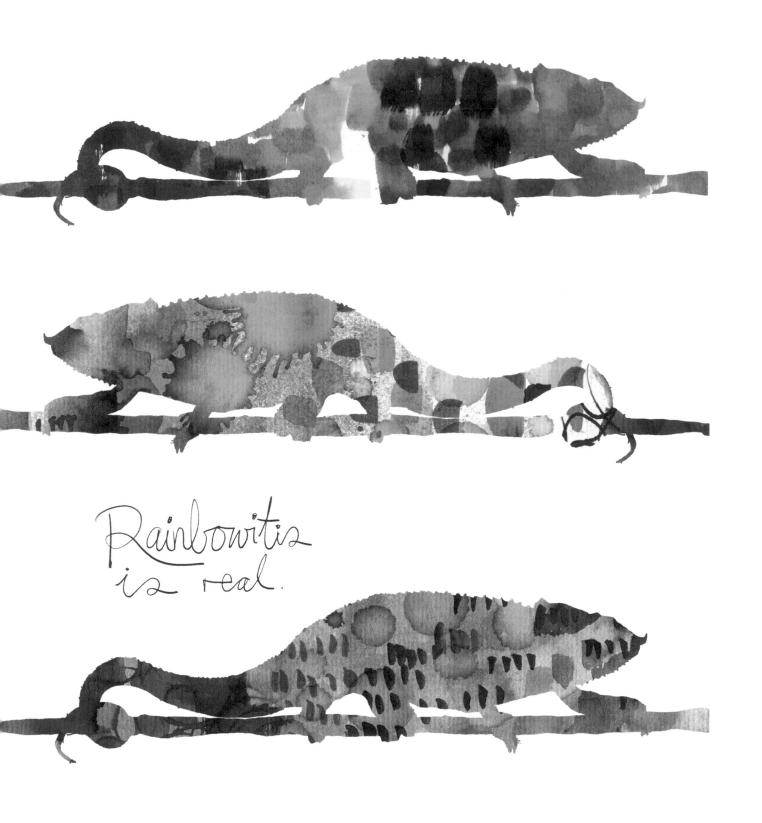

Rainbowitis
is real.

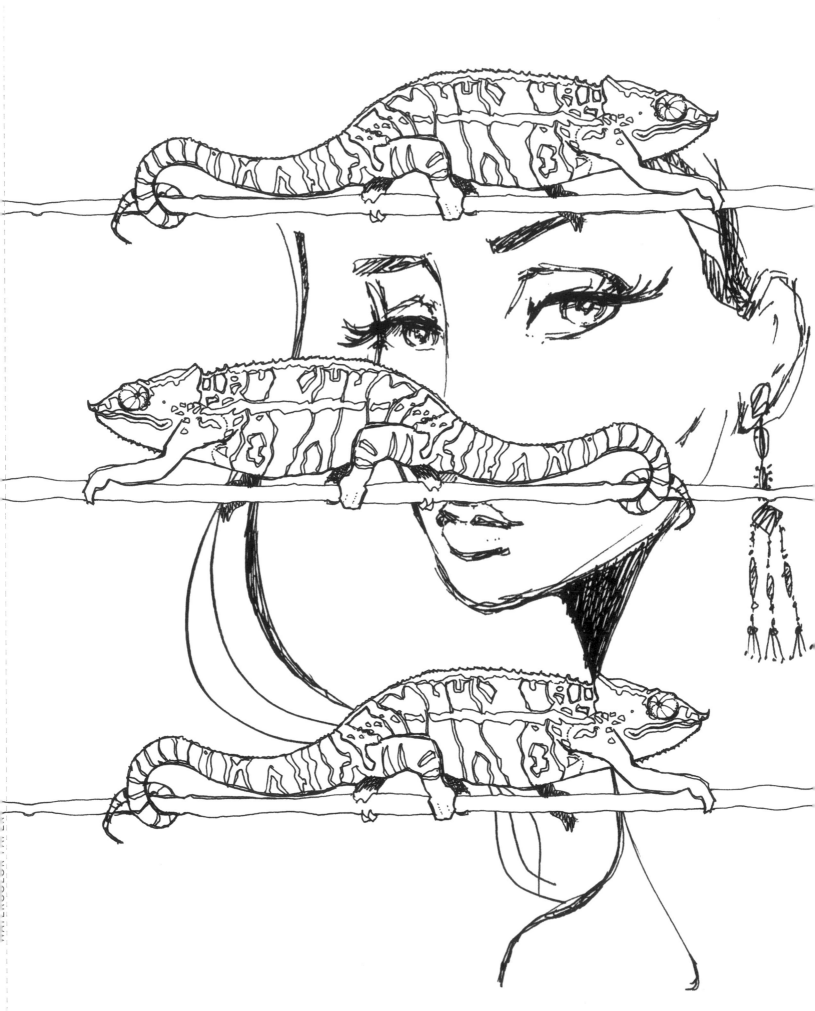

Sloth Wisdom:

Hang around your
loved ones.

Eat slowly.

Take your time.

SLEEP.

Love the trees.

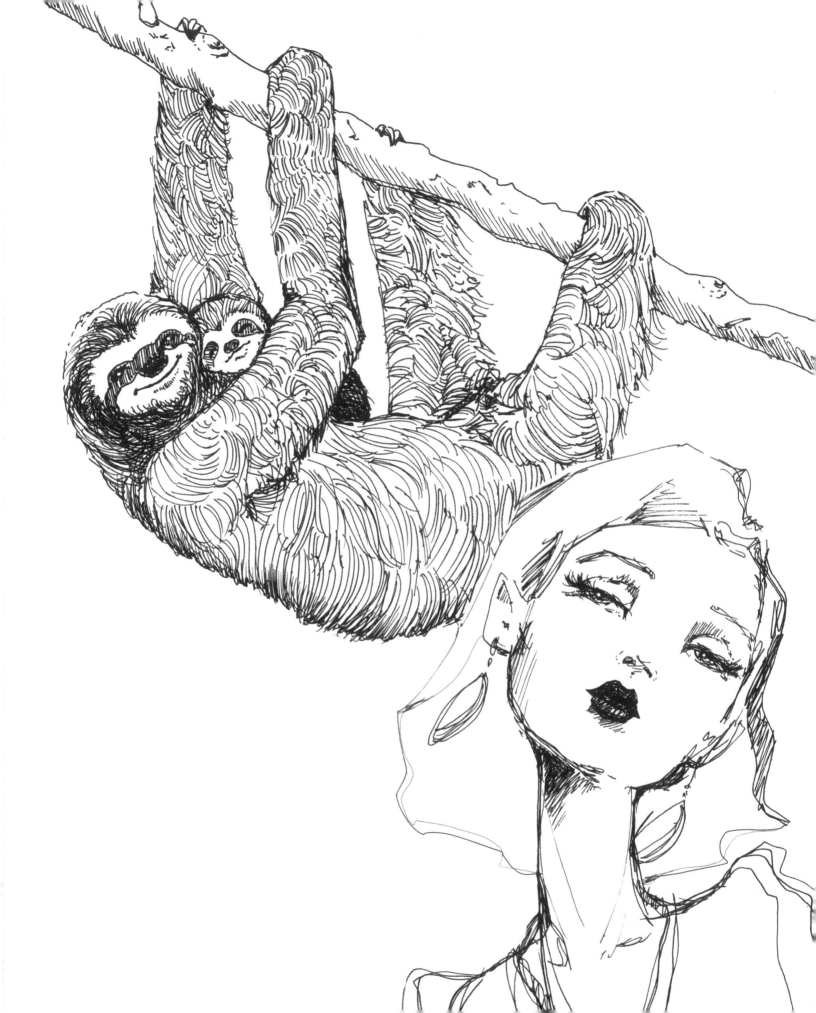

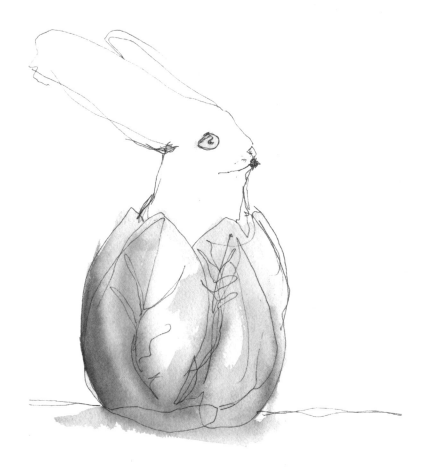

Join me at www.janedavenport.com for
examples on how to use this book!

Use #janedavenport
and #whimsicalandwild on social media
so I can see your pages from this book!

.xoxo
jane

#janedavenport #whimsicalandwild

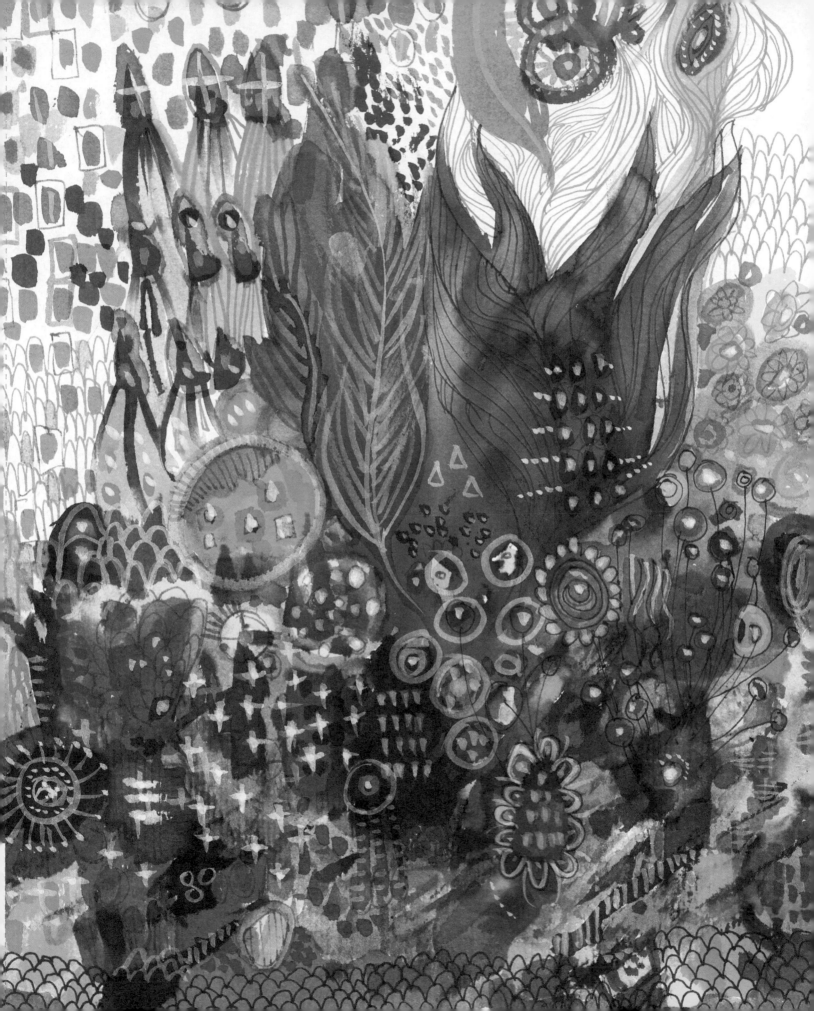

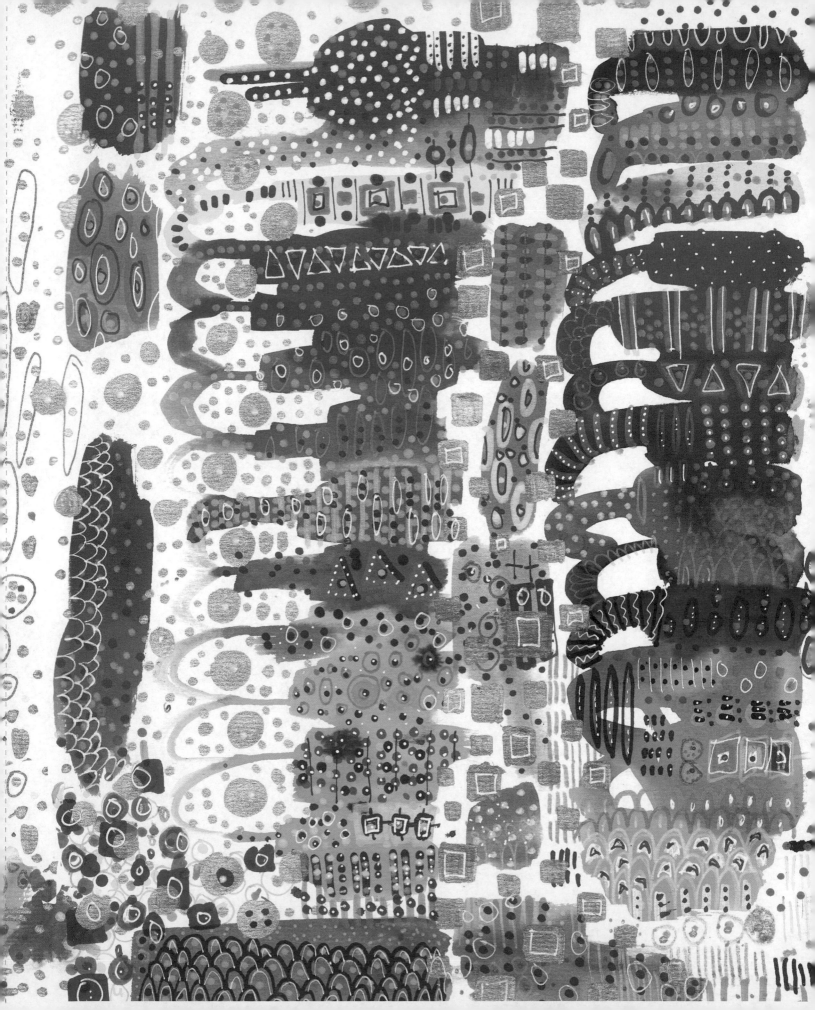

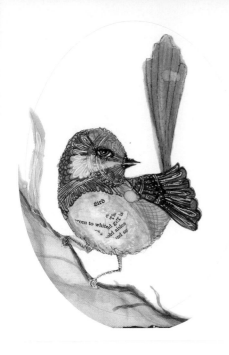

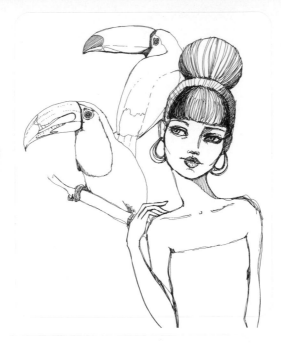

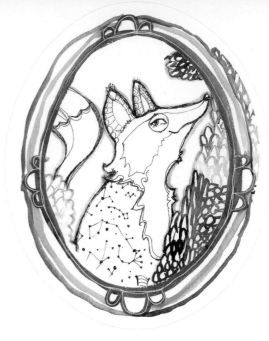

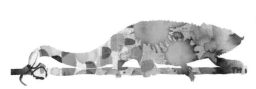

Rainbowitis is real.

Throw me to the Wolves, and I will return leading the PACK.

Sway your hips, Dance and Dream

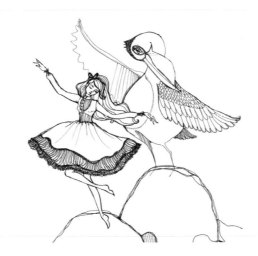

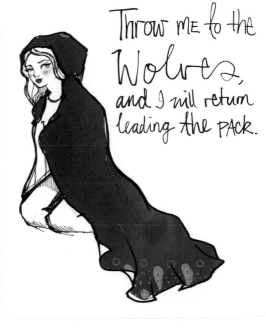

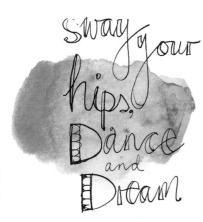

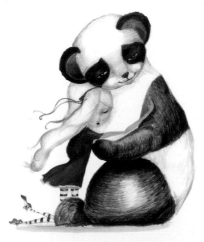

never stop dreaming

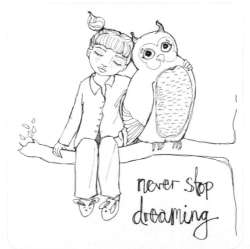

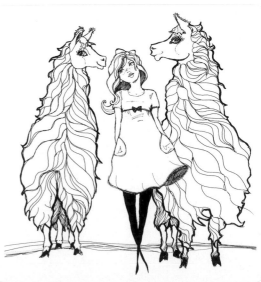